SCULPTURE

Significantly different versions of several essays have previously appeared in the periodicals *C Magazine, Parachute, Boo Magazine, Canadian Art.*

Cover art: "Crystal II, Representation of a Selenite Gypsum Crystal", 1993-2003, carved gypsum plaster, 29 x 64 x 28 cm, by Robin Peck. Photograph by Daniel Smith. Background: paste paper by Gallery Connexion, Fredericton NB.

Design and in-house editing by the publisher, Joe Blades.
Printed and bound in Canada by Sentinel Printing, Yarmouth NS.

The publisher acknowledges the support of the Canada Council for the Arts and the New Brunswick Culture and Sport Secretariat-Arts Development Branch.

Broken Jaw Press Inc.
Box 596 Stn A **www.brokenjaw.com**
Fredericton NB E3B 5A6
Canada

Visit the book's webpage: www.brokenjaw.com/catalog/pg94.htm

Library and Archives Canada Cataloguing in Publication Data
Peck, Robin
 Sculpture : a journey to the circumference of the
earth / Robin Peck.

Includes bibliographical references.
ISBN 1-55391-032-X

 1. Sculpture. 2. Peck, Robin—Travel. I. Title.

NB249.P4A35 2004 730'.92 C2004-904383-8

SCULPTURE

A Journey to the Circumference of the Earth

Robin Peck

Fredericton • Canada

For
Jason and Matt

"… once the Earth had been circumscribed as a sphere, as a finite space … what remained was the inevitability of a circular tourism wearing itself out in the absorption of all differences …"

Jean Baudrillard, *Radical Exoticism*, p. 147

Contents

Chapter I
Travels with a Sculptor

The Sculptor steps between stone and tree. I follow. We enter the Richard Serra exhibition at the Dia Center for the Arts. Between the sidewalk and the street along both sides of the last block of West 22nd street in New York City, are rows of vertical grey-brown prismatic stones. Each is paired with a small tree, a gingko, a pear, a sycamore, or an oak. It is an extension of the Joseph Beuys sculpture *7000 Eichen* (*7000 Oaks*).[1] The Serra exhibition *Torqued Ellipses* hasn't opened yet, and all around the sculpture the cement floor is cluttered with tools and equipment. A hose still trickles from an attempt to rust the surface of one steel plate. I pick up a scrap of paper off the floor. It has a sketch drawn on it, a plan for one of the elliptical sculptures. I stuff the map into the Sculptor's pocket.

[1] Inaugurated at *Documenta 7* in Kassel, West Germany in 1982 and completed in 1987, "They are basalt columns that one can find in the craters of extinct volcanoes, where they become a prismatic, quasi-crystalline shape through a particular cooling process ... each would be a monument, consisting of a living part, the live tree, changing all the time, and a crystalline mass, maintaining its shape, size and weight. This stone can be transformed only by taking from it ... never by growing. By placing these two objects side by side, the proportionality of the monument's two parts will never be the same." Joseph Beuys in Johannes Stüttgen, *Beschreibung eines Kunstwerkes*, Düsseldorf, 1982

Double Torqued Ellipse (1997), is an outer wall of three contiguous steel plates and an inner wall of two. It has a broken axis entrance, with outer and inner openings opposite one another. To reach the center we must walk between walls of steel. I follow the sculptor into the maze, moving counter-clockwise within the steel sleeve. I experience the sensation of descent. It is like being in an immense tin can, like descending into the bore of the *Columbiad.*[2]

At the lowest point we turn left into the central interior and for a moment stand facing one another.[3] Walking back, completing the circuit, we feel that we are ascending. The ellipse on the floor, which we follow with our feet, is twisted out of alignment with the ellipse above our heads, which we follow with our eyes. Between the ellipse above and the ellipse below is a vertiginous, curving steel surface, a smoothly flowing narrative that resists the gaze. Experiencing Serra's sculpture is a muscular exercise, perception mediated by the body. I watch the Sculptor's torso move with a gyroscopic alertness that quells my own vertigo. She and the *Double Torqued Ellipse* become *Discobolus.*[4]

I sketch the pieces from floor level as Jim Schaeufele, the Director of Operations at Dia, describes the installation logistics. He describes the pouring of a new reinforced concrete floor. The Sculptor and I describe our travel plans: Iceland by way of Transylvania, Paris, England ... and how in Iceland the Sculptor

[2] The gigantic cannon in Jules Verne's *From the Earth to the Moon.* Serra's steel plates are 2-inches thick, but the fictional *Columbiad* had 6-foot thick walls of iron. Jim Schaeufele, the Director of Operations at Dia, tells us that during the rolling of the steel at Beth Ship outside Baltimore, one of these eighteen-ton plates snapped with a sound "like thunder or a cannon." I have since heard this story repeated and further exaggerated each time, like the origin of a myth of Thor or Vulcan.

[3] "The centre of the ellipse is useless because of its two distinct focal points.", Gaston Bachelard, *La Formation de L'esprit Scientifique,* 1938.

[4] Myron, *Discobolus* (Discus Thrower), c. 450 BCE.

will cast a one cubic metre concrete sculpture of an Icelandic calcium carbonate crystal[5] and move it to a permanent location at the geographic center of the island. We show Jim the transparent calcite crystal that the Sculptor has in her pocket, now wrapped in the map that I found on the floor. While Jim talks about Richard Serra, his crews and his cranes, I am wondering how much weight the Sculptor and I can lift. Jim expects that the Serra installation photographs will be taken from the ceiling, like the view of a surveillance camera. I also intend to look at this sculpture, but from a distance, from someplace else.

The sculptor and I stroll back down the Carnac-like avenue of basalt pillars. She wants to build a full-scale hardwood replica of a sidewalk wheelchair ramp and slows to pace off some critical dimension. It is summer in New York. The pavement is hot under our feet.[6] I want to go uptown to the Metropolitan Museum, but she wants first to go downtown, to shop for shoes in Soho.

The Egyptian sculpture at the Metropolitan Museum is an assemblage of limestone, alabaster, plaster and ivory. Most of it is the colour of sand, like fragments of a pale desiccated body. What is left of Ancient Egyptian sculpture seems always larger than before; always more excavated and more exhibited. When he visited Giza on his way home to Paris from India in 1937, the sculptor Constantin Brancusi predicted that a great flood was coming and that sculpture would be lost in the sand. Indeed, sculpture made today always seems less, always smaller than it

[5] "In 1669 Bartholin discovered the phenomenon of double refraction on 'Iceland spar', a particularly clear variety of calcite from Iceland. Many crystals have this property of splitting an incident ray of light into two differently refracting rays. In calcite the difference in refraction is particularly large, so that any writing will appear to be quite clearly doubled." Hellmuth Boegel, *The Studio Handbook of Minerals*, 1968, p. 159.

[6] "We were walking over those massive, dark-gray rocks which the cooling process had moulded into hexagonal prisms," Jules Verne, *Journey to the Centre of the Earth*, 1874.

was before, more concealed and less exhibited, shrinking islands formed from the peaks of flooded mountains.[7]

Pieces of ancient Egypt are scattered like Humpty Dumpty in museums around the globe, a torso here and a head or a foot there. Complete statues are known to exist as parts in different museum collections, apparently never to be rejoined. I visit one small fragment in the Amarna Gallery at the Metropolitan Museum. I have been seeing her for years, the *Fragment Of The Head Of A Queen*.[8] She is just a mouth really, bright yellow jasper, the carved surface polished like a gem. Where once were nose and eyes and forehead are now conchoidal fractures, a mountain landscape seen at a distance. Broken statuary reveals material, geological and gemological facts that are normally obscured by image. Here the conchoidal fractures reveal the head of the *Queen* as a dense silicate mineral, a material difficult to carve but relatively easier to shatter.

If the Sculptor doesn't move, the glass box enclosing *The Queen* reflects her face, fitting her gaze onto that of *The Queen*, completing the portrait. Viewed from the side, I can cup their chins within the palm of my reflected hand.

"Sculptural energy is the mountain
Sculptural feeling is the appreciation of masses in relation

[7] The Sculptor once had a block cut at Ottavino Brothers, a custom granite yard in Queens. They were working for either the Metropolitan Museum or the Brooklyn Museum Egyptian Art Department. I don't remember which. I do remember the black Pennsylvania granite replica of a Donald Judd sculpture against a background of sphinxes and lotiform columns (as well as the entire front of Mark Twain's Greenwich Village brownstone). The appropriation artist Sherrie Levine, at the time a cartoonist of sorts, came by to see the work and commented that it was, "… a cool idea … making art of someone else's art".

[8] MMA acc. No. 26.7.1396.

Sculptural ability is the defining of those
Masses by planes."[9]

As we walk around the sculpture, I see a succession of planes defined by edges. The conchoidal fractures have formed the upper portion of the sculpture into an irregular hexagonal prism. The six different faces contrast with the lower surfaces, with the smooth uninterrupted flow of imagined flesh. I pause six times on my first circuit. Then around and around we turn, recarving the *Fragment* with our movements, turning it on our perceptual lathe. Each glimpse is a template, a facet that turns page-like into the next. And as we carve the sculpture, fragments of jasper yellow light fall as waste upon the floor.

The Sculptor draws my attention to a pile of garbage near a museum washroom. It is an island of gold when seen from a distance: the materials alchemically transmuted or purified by distance. Closer up, it seems to be a smashed translucent crystal, fractured along strange molecular axes, each fragment of light a differential replica of the whole. Closest, it reveals itself as a wave of detritus: mouldy white bread, broken eggs, masking tape, crushed cardboard architectural models, bits of plaster, broken glass, a crumpled yellow rubber raincoat, stained paper, cloth and chunks of yellow urethane foam, a sculpture by Aidas Bariekis.

Recall the lead "signature material" pieces that Richard Serra began in the late 1960s. This is not that. This pile is anything, but not everything. It just barely, and therefore sharply, embodies discrimination and choice. These materials are not piled atop one another into a careless sculptural narrative, layered without plot or subplot. Instead it seems an allegorical landscape, aspiring to the sublime. Here the material object is strewn as fragmented light in a zone between vision and corporeality, rendered vast not by the size or weight of the material but by colour. If there is a signature

[9] Henri Gaudier-Brzeska, "Gaudier-Brzeska Vortex", *Blast*, No. 1, 1914.

material here, it is colour. But it is not so much colour that is the material (as in the work of Anish Kapoor, for example) as it is the various materials that are themselves the colour. It is a urinal yellow-white, the impure white of stained ivory, very nearly and not white, or perhaps white but with a painterly or historic patina. On closest inspection, the colour separates and reveals each object as a stain along a spectrum. This is colour understood as a condition of found materials, the impure coloration of real objects. It is the matter of light understood by the Sculptor.

In a corner cabinet, the Sculptor discovers an Egyptian libation table[10] carved from pale limestone, an artifact of the First Intermediate Period from Lisht. This *trouve* looks like a torso, a model of the female reproductive system, the symmetry of channels and ponds at different levels. It seems a scale model, with canals, dikes and sluices all leading to its single spout. Perhaps originally for the votive mixing of chemicals, it reminds us that the ancient Egyptians invented both plaster and pharmacology.[11] The Sculptor wants to touch the stone table but it is behind glass. Frustrated, she instead detours us upstairs to illicitly caress the black and red granite *linga* in the Asian collection, and to look at a few Tibetan *mandalas*.[12] I distract the guard. The year before, the Sculptor was evicted from the Guggenheim Museum for spinning Brancusi's *The Fish* (1930) on its base.

On the way out, we innocently step down into the Halloween dungeons that are the Medieval Christian halls. Here the sculptural body is denied, emaciated and tortured, a dark place illuminated by white skeletons.[13] Even the best of this Christian sculpture has

[10] MMA acc. No. 32.1.213.

[11] Plaster is edible, used as a binder in pharmaceutical pills and a thickener in ice cream.

[12] (Sanskrit, "circle"; in Tibetan, kyil-kor, "center and circumference").

[13] In Herman Melville, *Moby Dick*, Ishmael believed his fearful reaction to whiteness proved the existence of something worthy of such fear. He argued that at least one aspect of the fear of whiteness derives from "the aspect of the

only the numinous appeal of sickliness, the eroticism of the anorexic fashion model. It corresponds to Nietzsche's vision of a morbid Christianity, a memorial sculpture that "has created for itself states of distress in order to eternalize itself."[15] The Sculptor stiffens, her body a hard fetish under the gaze of Catholic misogyny. But as she bends to admire some ivory carvings, so like worn plaster, she licks her tongue over her teeth, and turns her grin to me.

> "No material used in Sculpture is more seductive than ivory ... the touch is at once familiar and compelling ... anticipated ... in the feel of our own teeth to the tip of the tongue."[15]

> "... the consumptive girl, if she looked at herself in the mirrors, saw among all the whiteness the death's head ... and the white columns felt their plaster masks crumbling, and once again became the ruins of a vanished past which they had always really been."[16]

There is a skull behind the Sculptor's grin. She has described her visits to the dentist as sculptural encounters, all carving and casting, drilling and filling. We are each now sculpted into the appearance of health, our mouths brimming with classical columns of straight white teeth. The Sculptor recalls being resigned to the bondage of a dentist's chair while watching the immolation of the Branch Davidians at Waco on a live television broadcast. Their

dead — the marble pallor lingering there." He knew because he feared — a premonition of George Bataille's intuitions of Catholic architecture. Denis Hollier, *Against Architecture: The Writings of Georges Bataille,* 1989.

[14] Nietzsche, *The Antichrist.* 1888.

[15] Nicholas Penny, *The Materials of Sculpture,* 1993.

[17] Mario Praz, "White and Gold", *On Neo-Classicism,* 1924.

burned bodies were later identified from dental records. She remembers Waco, but it is a Waco scaled down to an ordeal suffered in a dentist's office, and her visit to that dentist scaled up as a memorial to Waco. She is not quite sure where she was when John F. Kennedy was shot, but in the Medieval Christian Halls of the Metropolitan Museum she is reminded of where she was during the immolation at Waco.

Behind the museum, is the Egyptian obelisk on Greywacke[17] Knoll. It took four months to roll this 200-ton granite monolith on iron cannon balls all the way from the Hudson river, across half the width of Manhattan.[18] It has been threatening to rain all day, and as we gaze up, the heavens open. Rain deflects off the pyramidion and directly down onto our faces. We run into the nearby automobile traffic overpass tunnel and wait out the shower. The sculptor smokes as we examine the map-like drawing that I found on the floor at Dia. The calcite crystal unwrapped sits at the center of the map.

The last drops of the thundershower have only stopped falling when we stuff the map back into her pocket, and step out from the shelter into the middle of the gleaming sidewalk. We set out, first the Sculptor and then myself, both imitating the "determined stride of a good walker who has lately realized that he will have to walk farther than he intended."[19] But after the circumambulatory experience of viewing sculpture at Dia, and then in the museum, we suffer from vertigo and have trouble walking in straight lines. Instead we trace first nearly parallel and then eccentric intersecting arcs back and forth across the width of the sidewalk. We stagger this way across Central Park to The American Museum of Natural History.

[17] Graywacke, Greywacke or Grauwacke is a hard stone, a schist or slate, usually gray in color, sometimes blue or green.

[18] Martina D'Alton, *The New York Obelisk*, 1993.

[19] C.S. Lewis, *Out of the Silent Planet*, 1938, pp 1.

Chapter II
DIA and the Dinosaur

When Dion Kliner changed the skull on the *Brontosaurus* skeleton at the American Museum of Natural History in New York, the dinosaur became *Apatosaurus*. It was as if he had changed a light bulb, illuminating the new paleontology. At the same time downtown, James Schaeufele, the Director of Operations at the Dia[20] Center for the Arts hired a crew of artists to change the tail on Katharina Fritsch's *Rattenkonig*. Between the two, between head and tail, a polymorphic sculptural body reared up and was formed.

Both Schaeufele and the Sculptor are graduates of the sculpture program at the Nova Scotia College of Art and Design. Schaeufele has been on hiatus for several years, but the Sculptor still makes sculpture in his Williamsburg studio. His *Snowball in Hell*, 1999,

[20] *Dia* is from Greek, meaning "through", although less in the sense of passage (as promoted in an official Dia brochure) than of all-pervasiveness, as in "throughout". It is in this sense that Dia as a pseudo-acronym takes on a humorously sinister cast. In a movie comedy from the 1980s (*Spies Like Us*) two KGB agents masquerading as American spies introduce themselves as agents of the D.I.A. In classical mythology Dia was a Lapith, a close friend of the hero Theseus. Dia (Naxos) is also the name of the Aegean island on which Theseus abandoned Ariadne and where she married Bacchus.

wax over plaster, is a coprolite petrified by the historical gaze.[21] The plaster is preserved beneath a coat of thick pale wax that softens the image and allows for the forming of simulacra. It recalls the sculpture of the Italian proto-Futurist Medardo Rosso. Schaeufele's sculptures from the mid-1970s were his last, small cast lead blocks that looked like ingots or architectural models. They were sealed in a trunk and buried somewhere along the coast of Atlantic Canada. A map was made. If the last century of sculpture has been criticized as being a neo-Neolithic of sorts, consider that as well as being an age of innovation it was also the great age of excavation. The golden funereal masks of Tutankhamun, the terra cotta army of Qin Shihuangdi, or any number of other excavated artifacts, were uncovered during the 20th c. Each day Schaeufele's sculpture seems more significant, heavier, more deeply embedded in earth and lost in time. Yet because of his position at Dia, his acquaintanceship with various noted artists and curators, each day his sculpture is more likely to be found and excavated.

When the Sculptor questions Schaeufele concerning his lengthy hiatus from the making of sculpture, Jim counters with a list of the work that he has made over the last two decades: pieces by Dan Graham, Dan Flavin, Robert Gober, Juan Munoz, Katharina Fritsch and Richard Serra, *et al*. While the Sculptor was hired to forge steel armatures, recreating *Brontosaurus*, *Stegosaurus* and *Tyrannosaurus Rex* at the American Museum of Natural History, Jim was overseeing the construction of exhibitions at the Dia Center for the Arts. He makes yearly trips out to New Mexico in order to check on the maintenance of Walter de Maria's *Lightning Field*, a one-mile by one-kilometre grid of four hundred stainless steel poles. A polished bulletlike point, a spare terminus for one

[21] *Snowball in Hell* recalls Albert Elsen's humorous and fatalistic remarks on sculptors: "(sculpture is) a losing proposition. Physically it's a loser. Financially it's a loser. Critically it's a loser. You don't have the critics on your side ..." (Albert Elsen, "Interview", *Sculpture*, (January-February 1995), pp. 10-13).

of the poles, sits on a filing cabinet in his office. Aside from this object, I have never seen the *Lightning Field.* I know it only from photographs, postcards from other tourists.

"There is no branch of detective science so important and so much neglected as the art of tracing footsteps"[22]

A study of the spectatorship of sculpture is akin to being a branch of Ichnology, the scientific study of footprints. Text, most likely invented in imitation of animal sign, cuneiform animal trackways in mud and snow, is the memory of hunting, of pursuant travel. The American Museum has a dinosaur trackway, a trail of footprints in stone, impressions of one dinosaur hunting another, excavated from the bed of a river in Texas, exposed by the rushing wear of water. Inlaid in the floor near this prehistoric text is a metal cladogram,[23] a path for the museum visitor. To follow this shining road is to be lead into small box canyons of glass and steel, cul-de-sacs of fossils. Instead we walk *au rebours,* against the flow of evolution.

The backrooms at both Dia and the American Museum are similar, built to the same large scale, with the same type of shop equipment. A crated Robert Gober exhibition blocks a hallway at Dia. At the American Museum, a hallway is blocked with a crate labelled *Paleoparadoxia.* Leading me into a storage room, the Sculptor stamps his feet loudly before turning on the light, saying that he doesn't want to see the cockroaches. Here are shelves of dinosaur bone specimens. One large unknown fossil is still enclosed in its unopened field jacket, labelled only "Red Deer River, 1917." I imagine that I can still smell fragrant Badlands sagebrush locked into the porous plaster surface.

[22] Sir Arthur Conan Doyle, *A Study in Scarlet.* London, 1891.

[23] A cladogram is a family tree of sorts, branching with the evolution of shared derived physical characteristics.

The Sculptor thinks that the paleontological digs of the future will be done in these close cluttered rooms rather than in the fragrant western Badlands. From a wooden drawer we take out several dinosaur eggs. These are the first and the most famous dinosaur eggs ever found, collected on expeditions led by Roy Chapman Andrews to Mongolia during the 1920s. Terra cotta red, they fit tool-like into the palm of the hand. They are the eggs of either *Protoceratops Andrewsi* or *Oviraptor Philoceratops*. I feel like the *Oviraptor*, the egg thief, for I am tempted to (but do not) pocket one. One specimen is larger, the eggs arranged in a circle, like a nest or a sculpture by Louise Bourgeois.

A film camera was set up high in a corner of the *Tyrannosaurus* shop for the length of the skeleton's reconstruction. The surveillance stole a frame or two each minute. The film is now shown as part of the *Tyrannosaurus Rex* display. It compresses the Sculptor's patient yearlong labour into only a few minutes, the movement of his body a frantically comic and ghostly blur against the slowly growing skeleton.

The Sculptor's steel armatures, bolted to the thick pipe that acts as a parallel backbone, twine as if Art Nouveau vegetation around each bone of the *Tyrannosaurus* skeleton. In a recent American Museum publication a photograph of the rebuilt *Tyrannosaurus* has the Sculptor's armature airbrushed away. The skeleton is seen to support itself. It is now held together by theory alone, without any trace of the rude physical signs of the sculptural.

In all sculpture we recognize the caryatid support for architecture, but there is no figure in the stone awaiting release, as the homilies of sculpture would convince us. There is instead a stone within our own bodies: fluorine enriched hydroxapatite crystals that form the basis for the process of petrification, the final stage of the increasing stiffness that is death. Consider National Socialist architect Albert Speer's use of living immobile persons, soldiers standing at attention, in his design for the entrance facade to the Berlin Chancellery:[24] Herman Melville's "eyeless statue in the soul" embodied within the architecture of the state.

"Return with me to stone all ye whom from stone were wrought."

— Alberich, King of the Dwarves,
in Fritz Lang's *Die Nibelungen : Siegfried* (1924)

The bones that survive the longest are the pelvis and the skull. As a sign of death, which is itself not death, but the thing that survives death, the skeleton is like the structure of the authority that orders death. However a skeleton is not much of a structure. Like any theory, it can easily collapse. Many fossil skeletons in museums are composites of several specimens supplemented by sculpture, by plaster and fiberglass casts.[25]

The process of refleshing fossil bone is an extension of the conventional studio practice of modelling clay over an armature. (The dinosaur sculptor Stephen Czerkas has modelled a seven metre *Allosaurus* directly over the cast of the fossil skeleton.) The informed speculations of paleontological theory and science fiction build upon this form. Only then does the dinosaurian simulacra arise.

The dinosaur as a sign for obsolescence is itself now obsolete. In popular culture, dinosaurs, "terrible lizards", have evolved from the slow-moving, dull-witted and cold-blooded reptiles invented by the Victorian science of paleontology to become relatively active, warm-blooded like mammals and birds, and relatively intelligent.[26] An American Museum publication lists the

[24] Robert R. Taylor, *The Word in Stone, The Role of Architecture in National Socialist Ideology*, 1974.

[25] The *Apatosaurus* in the American Museum consists of four different partial skeletons along with additional cast plaster pieces. The *Tyrannosaurus Rex* in the same museum owed its former upright stance to several entirely fictional plaster tail vertebrae.

[26] It is important to acknowledge the relativity of this intelligence. Recently, a paleontologist excitedly told me that some of the most "intelligent" dinosaurs might have been very nearly as intelligent as chickens.

smallest dinosaur as being *Mellisuga Helenae,* a Cuban hummingbird, still alive today, endangered perhaps, but certainly not extinct. In the American Museum at least, *Aves* has become *Dinosauria.*

The dinosaur functions as a dual sign for both extinction and survival. In 1991 a gigantic meteorite crater in the sea off the Yucatan peninsula of Mexico was discovered to be of the right age and in the correct location to account for the extinction of the last dinosaurs. Its impact 65 million years ago would have caused global darkness for months, coupled with an extreme greenhouse effect, a heat lid over the entire surface of the earth. Global cooling would have followed upon this and the radiant energy of the explosive impact would have caused atmospheric nitrogen to fall as acid rain. This scenario recalls fantasies of nuclear war and other modern environmental catastrophes.[27] (Dinosaur bones and uranium can be found together. The bones soak up and concentrate uranium during the process of petrifaction. One such radioactive bone is kept in the collection of the American Museum.) As earlier, now outmoded, conceptions of the dinosaur have been used in support of art critiques,[28] so the new dinosaur as constructed by the American Museum is a sign for cultural production in this new age of extinction.

Exhibitions at Dia normally last for one year. During 1993, Dia exhibited On Kawara's *One Thousand days One Million Years* and every month James Schauefele supervised the hanging of a different group of On Kawara's date paintings. Ten heavy volumes of printed dates, *One Million Years (Past),* and a sound piece, *One Million Years (Future)* were exhibited continually throughout the year. Under the "time is money" rubric of capitalism,

[27] A recent television advertisement claims that 100 species become extinct every day, the greatest level of extinction since the death of the dinosaur.

[28] Robert Smithson, "Quasi-Infinities and the Waning of Space,"*Artsmagazine,* November 1966.

On Kawara's work attempts and appropriately fails to keep pace with the vast scale of geological time (or the sublime scale of today's economy), in which one million years (and one million dollars) is no time (and no longer much money) at all.

"... the money themes are usually off canvas, that makes them all the more profound ... today art is all chic venality, cynicism and careering — the sublime if it exists at all is money."[29]

Many civic jurisdictions allow a certain small percentage of an architectural budget to be reserved for the funding of public art. Money is not thrown at public sculpture. Public sculpture is literally the spare change from the money that is thrown at the architecture. Sculpture made from metal looks like coinage.[30] Sculpture is displayed like so much silver (steel) or gold (bronze) loot from Scrooge McDuck's money bin. A middle class art audience that has made a fetish of bronze (which is actually a relatively cheap copper alloy) is unused to the large amounts of material normally displayed in any steel yard, and is relatively easy to impress with simple massiveness. Consider the thick lead and steel plates of any number of Richard Serra's sculptures, or painter Gerald Ferguson's work, *1,000,000 Pennies*, 1980, a conical pile of one million freshly minted (borrowed) pennies, a criticism of sculpture and a study of the economics of art exhibition

[29] Sami Rosenstock, "Money Themes". *Women Artists News,* Winter 1989.

[30] Consider that as sculpture is coinage, so painting and photography are paper currency. In actual coinage, "sculpture" traditionally refers to high relief modeling (i.e. the American buffalo nickel, 1913-38) or to simple massiveness (the 43-pound ten daler coin of 17th c. Sweden). Coinage has weight and substance, a conservative gravity that paper money cannot provide, but it is still secondary by virtue of its clumsiness, its inconvenience as a medium of exchange. Recently, coins have regained some measure of usefulness as vending machine tokens.

and acquisition. It is appropriate that public sculpture, as spare change, is so often displayed in front of banks.

Back when bigger was always better; Andrew Carnegie wanted something "as big as a barn" for a new wing of his museum in Pittsburgh. In Colorado, at what is now Dinosaur National Monument, his employees found a dinosaur, a *Diplodocus* that was literally that big.[31] The skeleton was excavated, moved east and re-erected in Pennsylvania. Capitalism literally displaced the sublime from the western landscape to the eastern economy. When once upon a time it was the landscape that was too big to think about, now it is the economy that is vast.

Capitalist institutions are embodied in the Brobdingnagian architecture of the city. Skyscrapers are capitalist statuary, and statues by definition are static. They do not move except during construction or destruction. Sculpture, as an architectural fragment, as a small differential replica of the whole, is what we salvage from ruin. Giant "dinosaurs" pose with buildings in the imaginary cinematic destructive climaxes to the constructive narratives of architecture, witness *The Beast from 20,000 Fathoms* in New York, *Godzilla* in Tokyo, The *Brontosaurus* of *The Lost World* in London, the *Tyrannosaurus Rex* of *Jurassic Park*.

As sculpture becomes architecture and architecture becomes institution, so institutions become histories and those histories are exaggerated into mythological giants. Dia and the Dinosaur are giants no less than Reygok[32] and Og,[33] no less than Paul Bunyan, Babe the Blue Ox, and the Woolly Mammoth.[34]

[31] H.J. McGinnis, *Carnegie's Dinosaurs*, Carnegie Institute, Pittsburgh 1982.

[32] The Croatian stone-counting giant of Icebor.

[33] Who survived the Biblical flood by hiding on the roof of Noah's Ark.

[34] Fossil bones were previously claimed as the bones of human giants — the mammoth skull with its huge nasal cavity as that of the one-eyed Cyclops *Polyphemus.*

" 'It's just the very biggest thing that I ever heard of!' said I, though it was my journalistic rather than my scientific enthusiasm that was roused."[35]

By the latest definition nothing more recent than 10,000 years old is considered to be a fossil.[36] But when Georgius Agricola (1490-1555) coined the term from Latin it simply meant something dug up from the ground, with no very great distinction being made between petrified bones, minerals and buried statuary. Even today, fossils and sculpture easily conflate, the petrified bone with the statue.[37] Sculpture exhibitions appropriate the aura of the natural history museum.

Most dinosaur art these days is genre painting, prehistoric "wildlife art", science fiction conflated with the art of the*animalier* and only thinly disguised as scientific illustration. Dinosaur sculpture is more interesting than dinosaur painting to the degree that it can be confused with actual fossil displays and museum stagecraft.

The paintings of Charles R. Knight (1874-1953) are well known as book illustrations. He depicted his *Brontosaurus* as a Victorian "terrible lizard" mired up to its hips in prehistoric slime. Sculptor Robert Smithson (1939-1973) wrote his essay "A Museum of Language in the Vicinity of Art"[38] after seeing Charles R. Knight's murals. He associated Knight's dinosaur with petrification and immobility in art. Appearing on a television program in the

[35] Sir Arthur Conan Doyle, *The Lost World,* London, 1912.

[36] For instance, the mold of a dog found buried in volcanic ash at Pompeii is too recent a formation to be considered a fossil.

[37] Dia was founded on a fossil fuel fortune. The collection of the Dia Center for the Arts, approximately 1000 pieces by Joseph Beuys, Dan Flavin, Donald Judd, Walter de Maria and other artists of the period 1960-1980, was assembled by its founders, Shlumberger oil-drilling heiress Philippa de Menil Friedrich and her husband Heiner Friedrich.

[38] *Art International,* 1966.

early 1970s, Smithson gave something of an artistic weather report. Facing the camera across a mirrored table he monotoned that, "a certain amount of aesthetic fatigue seems to have set in."[39] With the 1960s over, Knight's *Brontosaurus* was invoked as a sign for a moribund art scene.

Smithson understood the dinosaur as a sign of extinction. But he did not understand it as a sign of survival. After all, the new, active and intelligent dinosaur had barely been born when Smithson died. The American Museum recently restored Knight's wall murals. But his smaller paintings are displayed as artifacts in showcases with the fossils, behind polished glass that makes them difficult to see.

In a backroom closed to the public is a large table covered with small sculptures of dinosaurs. There is one plastic *Godzilla*, but most are plaster casts by Charles R. Knight. A few years ago the American Museum needed storage space, so they handed the Sculptor a sledgehammer and ordered him to destroy all of Knight's original moulds. He did it unwillingly, keeping for himself one small fragment of a mould with Knight's signature.

"Jack the Giant had nothing to do,
so he made a hedge from Lerrin to Looe"

traditional English rhyme

If every age gets (the dinosaur and) the Stonehenge that it wants, then Dan Graham's *Rooftop Urban Park Project Two Way Mirror Cylinder Inside Cube (1981/1991) and Video Salon* atop the Dia roof is a contemporary Stonehenge of sorts. Artists and art critics are attracted to the authority of architecture like insects to the lamp. Jeff Wall wrote[40] on Graham's work as being a critique

[39] *Here Come the 70s* televison program.

[40] *Dan Graham's Kammerspeil*, Banff, 1983.

of conceptualism that conflated the discourse of the glass skyscraper with that of the suburban house. Wall acknowledged the conventional history that an early model for glass architecture was Bruno Taut's *Glashaus[41]* and that the conceptual model for Taut was the work of fantasy writer Paul Scheerbart.[42] He further accepted that the model for Taut was Sir Joseph Paxton's iron and glass hothouse, the *Crystal Palace*, built in London for Crown Prince Albert's Universal Exposition of 1851.

The *Crystal Palace* had another smaller iron cage at its center that enclosed the 186-carat *Koh-i-noor*, (Mountain of Light) diamond. By the construction standards of the *Crystal Palace*, the diamond was a contradiction. It was transparent but also monolithic, revealing of nothing but itself. When the fair closed, the *Crystal Palace* was removed to the suburban park at Sydenham. Here the grounds were appropriately landscaped and populated with sculptures of prehistoric animals moulded by the sculptor Benjamin Waterhouse Hawkins. He nearly completed a similar display for New York's Central Park but they were vandalized, smashed to pieces and buried in the park. Some are still there, buried under the small hill near the pond at the corner of 59th Street and 5th Avenue.

Jeff Wall arrived at the dramatic "Vampire" conclusion to his essay on the basis of the ability of transparent glass to transform itself into a mirror when backed by the blackness of night. But night is not only darkness, perhaps not even darkness, and the night of utopian glass architecture is colourfully floodlit.[43] In a history of transparent glass architecture to Dan Graham, as derived through Paxton, Scheerbart and Taut, the seminal work must be Thomas Edison's ubiquitous light bulb.

[41] A pavilion for the German glass industry, built for the 1914 Werkbund exhibition in Cologne.

[42] Selections from Paul Scheerbart's texts appeared as a frieze on the outside walls of the *Glashaus*.

[43] Paul Scheerbart, *Glasarchitektur*, 1914.

Dan Graham's rooftop project recalls the lens of a pharos.[44] James Schauefele claims that on certain days of the year the glass cylinder focuses sunlight, like a magnifying glass being used to light a fire. He is afraid that the roof will catch fire. You can get a coffee on the roof, but you can't smoke. While having lunch with Dan Graham, I asked him if he would mind if I smoked. He said that I could blow it right in his face; that he wouldn't mind because he was from New York. I blew it right in his face. But one can't smoke in many New York restaurants any more.

We watch as a young woman walks around the dinosaur display at the American Museum. It is closed to the public. She is smoking a cigarette. She stops to adjust something in the display, and then adjusts her jacket and her hair in the reflective glass of a display case. The Sculptor tells me that she is the head preparator: smoke and mirrors.

When we enter a museum, we shiver as we catch wind of the tomblike mustiness. Following the prescribed routes to knowledge, our movements and the relationships between us become increasingly stiff and formal. It is as if the preservation applied to the objects in the collection somehow glazes over us during the period of our visit. For the most part, we obey the strictures against touch and photography. Photography is a form of touch, all the more invasive for its obsequiousness. At Dia, I do not photograph the exhibitions, but take my pictures in the back rooms where I have been given permission to do so. At the American Museum I do not photograph the public galleries, where I am allowed to, but instead take photographs in the back rooms where I do not have permission.

When we leave the museum, we pause at the giftshop and the bookstore, seeking some small release from the denial of the tactile. At the American Museum this denial is not exactly

[44] For a history of the previously unsuspected use of the lens in antiquity see Robert Temple, *The Crystal Sun*, 2000.

sublimated, but it is reduced to the scale of jewellery and books. In the face of the gigantic institution, we are inexperienced children again, taught in the classroom of the gift shop. And the lesson we learn is that it is necessary to purchase in order to touch. At the American Museum, there are fossil replicas for sale. Once you could buy "cold-cast bronze" (plastic resin mixed with bronze powder) sculptures of the Mongolian dinosaur eggs that the Sculptor and I have just juggled in the backroom. Those replicas included a sculpted baby dinosaur, a *Protoceratops,* emerging from a cast of an actual petrified egg. But they don't sell them any more. It seems that the paleontologists were completely wrong about which dinosaur species produced the eggs. The new egg replicas on sale are brightly painted casts of these same fossil eggs, but now they have a little sculpture of a dinosaur embryo curled up inside, an *Oviraptor Philoceratops*, the dinosaur that was once thought to prey on these eggs. The same egg has now produced two entirely different species of dinosaur (sculpture). The older reddish-brown "bronze" model was almost the colour of the original egg, the colour of a fossil bone or a bronze by Henry Moore, the colour of things dug up.

At Dia, the catalogue and magazine rack has been expanded into a veritable library, a series of architectural facades that grow incrementally with the procession of exhibitions. Contrast the sedate, archival pace of this growth with the rapid turnover of any popular magazine stand, the monthly, weekly, even daily replacement of text, the quick flickering of the architectural facade.

A Lawrence Weiner exhibition at Dia is like a huge expensive exhibition catalogue. We shrink in relationship to the gigantic scale of the wall text. Its aura is that of the exhibition catalogue, a sycophancy designed to suit the viewing habits of an overclass of art fabulators: curators and critics, those who pretend to a degree of control over the production of an underclass of art fabricators. Its authenticity is located in its ability to merge with the art institution, a mutually beneficial collaboration of the

obsequious with the officious. It is vacant of all but formalized postmodernist clichés, picturesque, faithless, deceitful, and smart — a beautiful art unencumbered by ethics or passion. The erotics of its avarice supplant strong emotion. It is clean, neat and looks like art from an art magazine. It recalls the lost ambitions of minimalism.

The set of polyester resin rats, *Rattenkoenig* that Katharina Fritsch exhibited at Dia in 1994 seemed huge in the gallery and they now seem even larger when James Schauefele and the Sculptor peer into their storage crates from above. The Sculptor wonders aloud how long it took Fritsch to make the piece. Schauefele replies that he doesn't think it took very long at all, that no one makes their own art any more, that everyone has a crew. He put together the crew that remade the plaster ball of intertwined tails, so like the convoluted surface of a brain, at the center of the *Rattenkoenig*.[45] Hands made this work, but they are now very nearly anonymous hands, their touch reduced to a list of names in small typeface in a Dia brochure, their labour blurred into anonymity like the image of the Sculptor in the Tyrannosaurus film.

Again, the Sculptor stamps his feet in ritual as he leads me into a dark storage room at the American Museum. This time he says he wants the rats, not the cockroaches, to disappear before he switches on the light. There are a lot of fossils in this room. Every time a paleontology museum restores its public halls, it seems that more material is put into storage and more fiberglass replicas are put on display. The Sculptor compares this tendency to an art gallery in which the works on display are competent forgeries at best and speculative additions to an artist's *oeuvre* at worst. He questions whether paleontologists would accept such a display as constituting an art gallery, since they expect one to accept a display of fiberglass sculpture as a museum of paleontology. Consider an

[45] The Sculptor worked on this crew. According to Fritsch, the original plaster lacked "integrity".

art museum of the future devoted exclusively to appropriation art.[46]

The practice of storing the real fossils in backrooms for research purposes also serves another function. It conceals from the public the very small amount of fossil evidence that many reconstructions are based upon. Entire animal species, even entire ecologies, have been fabricated from a single fragment of fossil bone, a legacy of the techniques established by the French Baron Cuvier.[47] The early 20th century paleontologist Henry Fairfield Osborne initiated the display methods still used at the American Museum. He hired the painter Charles R. Knight. Osborne also identified the first human ancestor in the Americas on the basis of a single tooth, a fossil pig's molar.

"All a fake", he repeated. "All of it, from start to finish. Bogus fossils salted into the rocks. Fake footprints. Planted evidence, everywhere."[48]

"Tyrannosaurus Rex couldn't have visited New York even if it had wanted to. A shifting sea separated Eastern and Western North America ..."[49]

You can't see the Red Deer River Badlands until you're in them. The canyons come up unexpectedly, from below the horizon. Roads cross over them only in short sections. When hot the

[46] I have met one eccentric "fossil hunter", a collector who haunts museums rather than badlands, collecting (stealing) a bit of painted plaster here, a piece of plastic resin there.

[47] Honore de Balzac on Cuvier, "reconstructing whole worlds out of bleached bones ... filling the void; he examines a piece of gypsum, observing an imprint and lo, marble becomes flesh and the dead are quickened to life."

[48] Roger Macbride Allen, "Evolving Conspiracy", *Dinosaur Fantastic*, 1993

[49] Jack Horner and Don Lessem, *The Complete T. Rex*, 1993.

atmosphere is fluid and in the distance the landscape ripples like water. During the winter everything is frozen solid. Automobiles drive through here with their windows always rolled up, either air-conditioned in the summer or with their heaters turned on full blast during the winter. Seen through windshield glass, the Badlands look like a museum exhibit. Because of this limited access, they remain largely unvisited except for a few hundred yards on either side of the roads. Behind this zone littered with pull-tabs and cigarette butts, extends the graveyard of fossils. It is a maze of canyons built from loosely consolidated sediments, sandstone, shale, ironstone, and clay. These are the geological formations of the Late Cretaceous, the age of chalk, the age of mass extinction. Here once were the shores of the Niobrara, the vast shallow inland sea that occupied the center of North America during the age of dinosaurs. Where once were living dinosaurs, ammonites and oysters, are now found their fossils: moulds and castings from the same.[50] One comes upon the bones of cattle and birds (lightweight and white) together with the broken bones of dinosaurs (heavy and dark) among the fragments of petrified wood and the stone casts of oysters. Every spring new fossils erode out of the cliffs and uncollected, crumble into fragments, surprisingly fragile for objects made of stone.

In the slanting light at the end of the day, the cliffs loose their stratified flatness and glow with detail like polymorphous architecture. In places there are so many fossils that in the twilight one cannot help stepping on some of them.

Tired after the climb out of the Badlands, the Sculptor is sitting on the edge of a cliff as he explains to me why he hated the movie *Jurassic Park*. He explains that he didn't think the dinosaurs looked real. He proposes that because of our familiarity with the

[50] Local Siksika (Blackfoot) myth tells of the old man, Napia, who lay down to rest during his creation of the world. When he arose, the impression of his reclining body, a mold, remained as the form of the Red Deer River valley.

animation techniques used in movies like *Alien*, the dinosaurs of *Jurassic Park* have been compromised, and are more unreal than ever. He complains that dinosaurs are everywhere these days: in toy stores, in books and in movies. He goes out west to the Badlands because it is the only place left where he can get away from dinosaurs. He searches for and collects dinosaur bones as if only to confirm their extinction. No Dia or dinosaurian simulacra arise here. It is only later as we drive through an oilfield on the way back to a highway, that a big blue and white Schlumberger oil rig truck pulls on to the road ahead of us. Through the dust unclearly the guy in the cab of the truck looks just like James Schauefele.

Chapter III
A Circumambulation of the Transylvanian Plateau

Bucharestii is a dispirited Asian Paris, ruinous and overgrown by vegetation, like a salad gone bad. In the suburbs of the city there is an open-air architectural Living Museum, consisting of hundreds of structures brought from all regions of the country, a kaleidoscopic overview of indigenous dwellings, stables, sheds and poultry houses, barns and wells, monumental gateways and wattle fences. There is a sod-and-timber structure like a Neolithic earth lodge, decorated with chicken feathers, cockscomb and wattle, a rooster house. The museum is lifeless. There is no one here except custodians and some few fellow*turistica*, like a village depopulated by massacre or famine.

In contrast to the empty museum are the miles of congested concrete apartment blocks that surround the city. The masonry is poor, grey piles more like ruins than like new construction. We drive west into the Wallachian countryside, past rows of daub-and-wattle houses, plastered with a blue wash, clustered together along the road, aspiring to villagehood. Yet, the countryside is as curiously depopulated as the Living Museum. It seems populated only by the old and infirm or by the very young. The rest of the people work in the ruinous factory cities, at least during the daylight hours. Some must return under cover of darkness, like *strigoi* (vampires), to haunt their family homes by night. The

Living Museum of Bucharestii takes on a new aspect as a memorial to the depopulation of the countryside: the "Museum of The Living Dead".

As we drive into Tîrgu Jiu I wonder aloud if we will easily locate the Park of Brancusi, his *Coloana Infinitului*, his gate and table. Will they be anonymous within this greater living (dead) museum? But I see the *Endless Column* almost immediately, an erect patrician above the odd-angled jumble of television antennae. To the east of the town center is the *Column* and beyond it, the *Table of the Feast*. To the west is first *The Gate of the Kiss*, at the entrance to the Park of Peace, and then, on the bank of the river Jiu, *The Table of Silence*, surrounded by its egg cup stools. The entire *Ansamblul Sculptural De La Tîrgu Jiu* is a symmetrical alignment on an east-west axis centred on the *Basilica of the Apostles*, constructed on an even older church site at approximately the same time as the rest of the *Ansamblul*, 1927-1937.

We passed by many small graveyards on the way to Tîrgu Jiu. In these, traditional pre-Christian serrated wooden memorial columns stand paired with the cruciform markers. Brancusi's *Ansamblul* is likewise a memorial to the dead, the axis flanked north and south by huge military graveyards. *Endless Column* is a monumental version of the serrated graveyard stake, driven into the collective heart of the military graveyard.

The Sculptor believes that he recognizes the form of a Romanian cross in the pattern of the recently constructed concrete pathways around the Column. A Romanian Orthodox congregation in Chicago recognizes such Christian symbolism in all of Brancusi's work, and revere him as a kind of saint. But at Tîrgu Jiu I am reminded more of the Vastu Purusha Mandala from Hindu architectural practice, with the building site conceived of as a human form, impacted face downward, imprisoned by a grid network of lines and stakes.[51] I am also reminded of Vlad the

[51] Kramrisch, Stella. "The Temple as Purusha." *Studies in Indian Temple Architecture.* 1973, pp. 40-47.

lmpaler, the Count Dracula, who skewered his imported Saxon peasants as a warning to the invading Turks.

"[In Romania] bodies have been exhumed ... stakes driven through the heart, pinning them to the earth ... At Zarnesti, after a female Vampire had been exhumed, great Iron Forks were driven through the heart, eyes and breast, after which the body was buried at a considerable depth, face downwards."[52]

To the east of *Endless Column* is the *Table of the Feast*, covered with turkey droppings. Poultry wanders nearby, also a cow, and a few gypsies huddle around a smouldering dung fire. The Sculptor takes photographs until a soldier armed with an automatic rifle runs toward us across the field from the direction of a low green building. He only speaks Romanian, and insists through hand gestures and jabs of his rifle, that we not take photographs of the *Column* that might include the low green building in the background. We give him cigarettes and continue to take the photographs. It will be difficult to photograph the lean of the *Column* from any other direction. The communists blamed the fascists for bending the column during an attempt to pull it down with a tractor, and vice versa. It is most probable that, although the iron spinelike shaft of the *Column* is anchored in an immense underground cube of concrete, this block has shifted over time. The Romanian landmass is notoriously unstable, prone to regular earthquakes. The ground around Tîrgu Jiu is mostly gravel and sand.

"A Place Sheltered By Fragrant, Plants, Cool And Undisturbed, Spacious And Surrounded On All Sides By

[53] Montague Summers, *The Vampire in Europe.*1929.

Water Is A Good Site. A Place Full Of Human Hairs,
Gravel, Bones, Sand Or Thorns Is Not A Good Site."[53]

Brancusi's column is often supposed to derive in a general
sense from the repetitive geometric elements in Romanian folk
architecture. *Endless Column* is architectural in the opposite and
equally imprecise sense that the sculptural exists in architecture.
In architectural discourse the word sculptural is used most often
to refer to a representational (skeumorphic) building, secondly to
massive or trabeate structure, and then to almost any curved or
irrational form.[54] However, in the sense of a specific architectural
origin, the form of *Endless Column* will inevitably appear as the
topologically negative volume formed by the niches at the outside
corners of any log structure built according to a hexagonal log-
building technique. This is well illustrated in Hamlin's *Form and
Functions of 20ᵗʰ Century Architecture,* as well as numerously
along the country lanes of Romania. *Endless Column* does indeed
look like a topological inversion of an architectural element, but
then it also looks like a provincial version of Italian Fascist
architecture. Consider the entire *Ansamblul de la Tîrgu Jiu* as a
provincial Romanian production of its contemporary Italian
architecture.[55] And then again, *Endless Column* is also like hot

[53] *Visvakarma Manasara*, in N.K. Bose, *The Canons of Orissan Architecture.*

[54] The Hindu temple *Kailasanatha* of Ellora, Corbusier's *Ronchamp Chapel*
and Frank Lloyd Wright's *Guggenheim Museum* are often cited as examples
in varying degrees of the sculptural in architecture. A final version of *Endless
Column* was intended (by Philip Johnson) to be an inhabited Manhattan
skyscraper.

[55] The Italian Fascists after 1931 promoted a simplified neo-classicism. De
Chirico's painting *The Enigma of the Hour* was realized in Guerrrini, La
Padula and Romano's *Palazzo delia Civilta Italiana*, EUR, 1942. Brancusi's
Roman conceits were acknowledged by the inclusion of *The Gate of the Kiss*
as part of the background set of Ancient Rome in Fellini's 1969 film *Satyricon*.
The date of the film corresponds to the period of Brancusi's posthumous
re-emergence as promoted by minimalist sculptors such as Carl Andre.

steam rising straight into a cold atmosphere, a support for the Varcolac, the invisible vampire who eats the sun and the moon, rising on a thread spun by night.

Graffiti covers the lower accessible sections of *Endless Column*.[56] These signs are carved, scratched right through the bronze (over zinc) outer coating, exposing the cast iron beneath. Carving is an obsession in Romania. Every possible surface is notched, as if the very atmosphere is erosive. Where wood and chisels are inappropriate, galvanized sheet metal and tin snips replace them. Romania is a land persistently whittling itself away. This carving is like the grinding of teeth, the chewing of fingernails or the gnawing of knuckles, the sublimation of historic oppression.

Wood artifacts and the wood grain patterns swirling across their surfaces are signs for the natural and the authentic. Lumber never dies; instead it continually expands and contracts with changes in temperature and humidity. Timbers, full of insects and subtle vegetal rots, always seem ready to take root. Wood is common, soft, edible and easily worked. A wood-grain pattern is

[56] The cast-iron modules of the *Endless Column* were based on a single model made in wood by Brancusi himself. The project engineer was Stefan Georgescu-Gorjan. The modules were plated in 1938 with a "very pure golden-yellow" finish based on the artist's instructions. It has been poorly replated twice since its construction. After the rejection of an earlier restoration plan by Radu Varia (The column was taken apart but, like Humpty-Dumpty, could not be reassembled. It was also suggested the final finish be the same yellow paint as used for highway markings) *Endless Column* has very recently been restored to its original appearance. The restoration was a collaboration of the Romanian Government, the New York-based nonprofit World Monuments Fund (WMF), the World Bank and other Romanian and international institutions, art historians (including noted Brancusi scholar Sidney Geist), engineers, and conservators. The existing iron spine was preserved and the modules were plated with a polished yellow bronze finish that replicates the original. A Romanian engineering firm, Turbomecanica, cleaned and rust proofed the spine and repaired the modules. The column was reassembled with lightning protection and ventilation. The grafitti and the patina have been removed and the straightened *Endless Column* now gleams gold.

actually the consequence of a saw cut through the growth pattern of a tree trunk. The angle of the cut predictably distorts the symmetrical concentric appearance of the growth rings. A wood grain pattern is like an anamorphic representation of this concentricity, the map of an eccentric subject moving in odd orbits. In Romania we even see carved plywood. In plywood, the growth rings of wood have been exaggerated by the actions of the rotary cutter (plywood is formed by gluing together thin laminations peeled from a log). These flamboyant patterns seem evidence for a flowing natural rhythm, signs for the rural place and the pre-industrial time. Plywood recalls Arcadia.

Judged by the high standards set by European walnut (*Juglans Regia*), plywood is a poor material for the sculptor. European walnut is very hard, yet it is easy to carve. It cuts so cleanly that it nearly takes on the appearance of machined metal. Carving plywood is the very opposite. The opposing grain of each thin layer, laminated at right angles to next, makes it nearly impossible to obtain a clean cut. Carving plywood leaves a ragged, splintery surface, as if an insane rodent had gnawed it, and the surface sands into a rippling contour map of sapwood lowlands and dense heartwood uplands.

Direct carving is associated with the doctrine of "truth to materials"[57] and the discovery by 19th century artists of exotic hard stone and wood carvings in ethnography museums, but also with the emerging nationalisms (the "site-specificity" of indigenous folk arts that utilized native wood and stone). Initially, its practitioners included diverse artists such as the neo-Medievalist Eric Gill and the Vorticist Gaudier-Brzeska in England, the expressionist wood carvers Ernst Barlach and Ludwig Kirchner in Germany, Andre Derain and Joseph Bernard in France … and Brancusi. In Paris, Brancusi first modelled clay in the manner of

[57] *Materialgerechtigkeit.*

Rodin and then began direct carving in 1907 under the influence of Gauguin's 1906 *Salon d'Automne* retrospective.

These sculptors had an antiquarian understanding of the past. As historians seek pattern and causality, so the antiquarian seeks material evidence. Antiquarianism is time understood as a loss of understanding, to be regained through the reawakening of objects, typically the idealization of the material aspects of rural life. As the modernist sculptors attempted to duplicate the conventions of the museum artifact, so they can also be understood as antiquarians and prehistorians. Their neo-primitivism was an aspect of the general reaction against the environmental and social consequences of the industrial revolution.[58] It served as an antidote of sorts, but achieved only a moral victory over industrialism. We all now live in a world vastly more industrialized, polluted and socially fragmented than anything European artists could have possibly have imagined at the beginning of the 20th century.

Carving plywood is very nearly deliberately difficult, as if the ideology of direct carving was being used as a sign applied (or perversely misapplied) to an industrial material. Carved plywood reignites our memories of modernism and reminds us of our loss. The development of modernist sculpture during the first decades of the 20th century is an appropriate subject for the senescent art of the last decades. As plywood is an industrial material, heavy with synthetic glue, the values of wood disturbed with those of industrialism, so it is wood transformed by industry, in the process of being turned into a mineral, like petrified wood. As modernism is now memory, so sculpture is again a memorial.

> "[Vampires] ... are able in some mysterious way to absorb the vitality of fowl and bees, for example, and to concentrate this upon their own farmyards and hives, so that their hens

[58] "Truth to materials" was revived in Britain during the 1980s, as a "green" ideology, by the late eccentric English neo-Marxist art critic Peter Fuller.

will become plump and lay abundantly, whilst the poultry of their neighbours sicken and die."[59]

The smooth surfaces of Brancusi's sculptures seem very different from the edgy chewed decoration of the typical Romanian barnyard. But his sculptures of birds and eggs are images that are the very opposite to the reductive means of his *taille directe*. Their plump convexity connotes fecundity, a prosperous, fattened or pregnant state. Brancusi's oeuvre was a bird that laid golden eggs and his concern was always for vitality and prosperity. An animist of sorts, Brancusi believed that he could somehow reanimate inert matter through his carving. This obsession with vigour is a rural habit, a necessity for animal breeders and crop producers. Rural Romania is a vast *Animal Farm,* populated by pigs, chickens, cows and the water buffalo of the gypsy herders (*Bivolar)* that lend such a strange South-Asian aspect to the landscape.

In the evening at Tîrgu Jiu there is a promenade, with most of the eligible population out strolling the main street, up one side and down the other in a counter-clockwise direction. Military officers strut like roosters on patrol, confiscating attractive women from the enlisted men. Here is an atmosphere of repressed sexuality, as if at any moment the ideology of the farmyard will overwhelm that of the political party.

A day trip from Tîrgu Jiu takes us to Hobitza, Brancusi's home village. Along the way we pass a row of old Russian T-38 tanks firing their cannons into a hillside. A large sign nearby reminds us that photography is forbidden. Hobitza is a peasant hamlet with dirt lanes filled with furry pigs and little girls with brown blonde braids who run away laughing at our approach. The whole place has a braided texture, with fences, barns and outbuildings all made from tightly-woven willow branches. This is a tightly-knit peasant community: tight-mouthed and tightfisted. It has the peasant

[59] Summers, *The Vampire in Europe*, 1929.

virtues. It reminds me of my Viennese grandmother and the flowers that she carefully braided from twisted strands of human hair.

At Hobitza the Romanian government preserves Brancusi's childhood home. There is a large carved wooden gate leading into a front yard, a timber house, a well, and a wattle corncrib. The caretaker shows us how to operate the water well, the *shaduck*, with its huge counterbalanced tree trunk set on a fulcrum to act as a veritable perpetual-motion machine. We watch this movement, and then I watch as the Sculptor sips water from Brancusi's well.

"There is an essential contradiction between Sculpture and movement, a statue is something that stands, and the word itself comes from the same Latin root as the word 'static'."[60]

"Sculpture is the art of that which does not move ... of death and the tomb."[61]

I watch as the Sculptor critiques student work. All their work moves in some way, mechanically or otherwise. The students all sit and the Sculptor stands. He asks why all the sculpture moves. The students confer and then agree that movement makes sculpture more interesting. The Sculptor paces around the work. He reminds the students that circumambulation has been traditionally expected of the spectator. The producers of the work remain sitting, gazing at their moving works, as if they are watching television, only glimpsing the Sculptor as he stalks around them. The two attitudes seem irreconcilable.

The restricted movements of kinetic art are a form of stasis. The actual movement of sculpture, as with architecture, is the slow

[60] Herbert Read, *The Art of Sculpture*, 1956, p. 88.

[61] Sidney Geist, *Brancusi, A Study of the Sculpture*, 1967, p. 173.

movement of ruin. We can animate sculpture with our movement, but if we move too quickly we are unseeing, nascent Eloi in the ruin. The sculptural body in ruin has been the theme of various histories of sculpture over the course of the last century. In the 1930s the history of kinetic art was characterized by Lazlo Moholy-Nagy as being a development from carving through modelling to linear construction, and then finally to movement. Recall Carl Andre's similarly disintegrative minimal narrative history of 20th century sculpture: FORM=STRUCTURE= PLACE".[62]

Consider Vladimir Tatlin's wooden model for a proposed 1300-foot tower, the *Monument to the Third International* (1920). The actual building was to have a steel frame containing, in vertical sequence, a glass cylinder, a tetrahedron, a cube and a cone that would rotate once a year, once a month, once a day, once an hour and contain the various meeting halls for the Soviet congress. Tatlin brought the Keplerian motions of the solar system down to earth and embodied them within the architectural body of the state. His tower was intended as statuary, a monumental image of a striding figure. It would bridge the Neva River as a new *Colossus of Rhodes*, a gigantic version of Italian Futurist Boccioni's striding figure, *Unique Forms of Continuity in Space*, 1913. In Tatlin's original model a small boy imprisoned in the base turned a crank to animate the internal organs of the body politic. Tatlin's tower exists only as various models,[63] but it did serve as a model of desire, a prototype for a century of art as material embodiment and disembodiment.

Naum Gabo's *Kinetic Construction (Standing Wave)*, also of 1920, a single shaft of motorized vibrating metal, was one of the first in a number of works by various artists[64] that led sculpture

[62] Diane Waldman, *Carl Andre*, 1970, p.6.

[63] It has been recently "built" as a virtual project in the *Unbuilt Monument* series of the Takehiko Nagakura / MIT ARC GROUP.

[65] Among them Moholy-Nagy's *Light-Space Modulator (Lichtrequisit)*, 1922-

away from architecture and gave kinetic art the status of a fetish, a metonymic portion of Tatlin's complex vision of a sculptural social body. Post-World War II artists working in the nihilistic shadows of European Neo-Dada and American Abstract Expressionism extended the idea of kinetic art as a representation of material disembodiment, the immateriality of Yves Klein (*Double Sided Wall of Fire*, 1961) and the quasi-Luddite dematerializations of Jean Tinguely.

Yet for all its frantic attempts to replace the material with the energetic, kinetic sculpture failed as a movement. It never really went anywhere. Sculpture remains static. Here and there kineticism lingers on as an anachronism, twitching bits of a dismembered body of practice.

On a geological survey map a small cross marks the location of a rocking stone, just outside the city. We drive on gravel and then walk along the dirt road that leads out onto a flat spruce bog. The road declines to a trail and then suddenly ends at the shore of a small, weedy lake. Nearby are some dilapidated picnic tables and litter. They signify this as a sometime site of leisure and celebration. Set back from the lake, just visible through the screen of trees, is a huge erratic glacial boulder. Seen in this way it seems alive and threatening, an ice age animal, a mammoth. We approach and find the rocking stone in a clearing by itself, perched on a sheet of exposed bedrock, a grey granite monolith. The base rock is engraved with long scratches, the insignia of the sliding glacial mass. The boulder is approximately three metres high and almost five metres long. A log is wedged between it and the sheet of bedrock. Using this as a lever, we are easily able to get the boulder rocking. It moves slowly and quietly, as if reliably, with a measured grace. There is no overt violence to this movement, but as I push myself against it, I am myself pushed away.

1930, a mechanism that resembles nothing so much as an obsolete time machine, an all too accurate parody of H.G. Wells' fictional Victorian contraption.

On the road back to Tîrgu Jiu we see long caravans of Tzigane Gypsy wagons that are nothing but woven willow baskets overturned and fitted with axles and wheels. The gypsies are moving south at this time of the year, to the warmer lowlands near the Danube. There is construction work going on behind our inn at Tîrgu Jiu. In the morning I watch as a soldier brings a group of prisoners to work. He is armoured against the cold in a wool greatcoat and large fur hat. The prisoners have no hats and wear only thin grey and black striped pyjama-like costumes. The soldier puts down his rifle and assists the prisoners in the construction of a wooden-framed wire cage, like a kind of chicken coop. When the structure is completed, the soldier picks up his rifle and herds the prisoners at gunpoint into the compound. There they remain for the day, engaged in the obscure tasks of construction. The soldier stands guard, nearly motionless, but shuffling his feet. At the end of the day, I bring the Sculptor to watch this communal effort repeat itself in reverse.

In the westernmost parts of the *Park of Peace* we discover some other of Brancusi's sculpture. There are, of course, his benches and stools placed along the broad central avenue between *The Gate of the Kiss* and the *Table of Silence*, one carved from a log, the others in stone. They seem somewhat dull and awkwardly proportioned. Plebeian in contrast to the erect column, they tilt and slump at odd sleepy angles. But there are others: hidden low beneath the bushes are a series of sculptures that Brancusi carved from debris during his spare time while supervising the construction of the larger works. They are small, compact, lumpy and white, coprolitic, as if the fossilized excrement of a very large bird. They appear as cumulus cloudings, obscure simulacra. There is also an anonymous work, an architectural folly of sorts, a monumental concrete sculpture of a tree stump with an iron door, possibly an attempt to disguise a gardening shed. As this petrified forest is scattered throughout with the white stony excrement of its former inhabitants, so it is another museum of the living dead.

The 17th to 19th century cult of the architectural folly was an imitative reconstruction of a fragmented antiquarian past, but historically speculative,[65] whimsical or eccentric. As a place of contemplative solitude, and as an exhibition of reason that remained pure by virtue of its withdrawal from the world, the architectural folly prefigures the ambitions of art over the recently past century.

Robert Harbison writes of John Sloan's London house as folly, museum and mausoleum, a recollection imbued with whiteness, plaster casts of heads and feet, marble statuary and architectural fragments, constructed "as if the ghosts from nearby graves have been summoned at once and come together in strange conglomerate life."[66]

> "[whiteness] has come to mean thanks to the practice of the centuries and to the very structure of our nerves, strength, cleanness and newness of sensation … [and] a capacity for re-enjoying the already enjoyed, for preferring the already preferred, for discovering new interest and pleasurableness in old things."[67]

Metaphors of the curatorial conjure up the spectre of a white collared priest, a custodian or keeper. Etymologically the curator is a physician charged with the care of a body of art, its longevity and its balance, its health. The curator is a conflation of Dracula

[65] See illustrations in Joseph Rykwert's *On Adam's House in Paradise*, 1972, of Sir James Hall's Gothic Hut (a speculative reconstruction of a Gothic prototype using wooden branch building techniques), Auguste Choisy's reconstruction of the timber origins of the Doric Order, Claude Perrault's *Latin hut after Vitruvius*, and the unique watercolor by John Gandy, *Architecture, Its Natural Model*.

[66] Robert Harbison, *The Built, The Unbuilt, and the Unbuildable*, 1991.

[67] *Vernon Lee*, "The Love of White", *Laurus Nobilis: Chapters on Art and Life*. 1909.

and Frankenstein, alternatively a vampiric leech collecting, then reassembling and reanimating the fragments of a corpse.

The blank white page, as if a northern landscape, produces discursive formations, mists and clouds that obscure the sensuous and concrete. Writings about whiteness are prevaricative as if by nature and yet text is also like the stitchings of a surgeon or a curator, a Frankenstein-like act of gathering up parts in order to reconstruct a whole.

"For some reason I have always hated plaster, the quintessential art-school material."[68]

The English aesthete Walter Pater, seconding Melville's "The Whiteness of the Whale",[69] wrote of the "mystery of white things ... ever an afterthought, the doubles ... of real things, themselves but half-real, half-material."[70] As aspects of Pater's half-reality, consider plaster moulds and plaster copies. Plaster has been traditionally used in the metal casting process, as an intermediary mould or a preliminary cast. As Pater's "half material", it can look like anything or nothing at all. It has been used as a gesso painted in imitation of marble or gold.[71] Along with marble and terra cotta, plaster is a paradigmatic material of classicism. Johann Wolfgang von Goethe expressed wonder at the plaster cast workshops of Rome and Johann Winkelmann defined his

[68] Carl Andre, "Robert Smithson: He Always Reminded Us of the Questions We Ought to Have Asked Ourselves", *artsmagazine*, May, 1978, p. 102.

[69] Herman Melville, Chapter 42, " The Whiteness of the Whale", *Moby Dick*, 1851.

[70] Walter Pater, Chapter II, "White Nights", *Marius The Epicurean*, 1903, p. 13.

[71] In painting, these preliminary and secondary characteristics of whiteness correspond to the initial priming of the canvas and, in interior architecture, to the drywall (plaster board) panelling of timber structure in imitation of a massive wall.

neo-classical body as if it was a topologically negative mould, an impression on a bed from which the flesh had already risen.[72] Winkelmann's neo-classical body evoked the rigidity of the corpse. His canon was a projection of personal desire, a love related to the numinous appeal of the sickly claiming to health.[73] Yet plaster is not necessarily classical in the sense of being the certain reasoning of symmetry, concerned with eurhythmic proportion derived from the natural model, but secondary to all this, a material suitable to an artificial ruin.

As a conventional sign for divinity, whiteness is faith, purity, innocence, chastity and by extension and perhaps dyslogically a sign for health, of the body, the home and the state. Plaster is calcination, bone, shell and horn, all milk, strong teeth and disinfectant whiteness. Neo-classicism has long been the language of political power, not restricted to totalitarian systems but the official style of many countries. Whiteness in art joins with neo-classicism, imperialism and colonialism in a system of petrification, that is the body of the state.

Plaster is also a paradigmatic material of early modernism. As a "half-material" it was suitable for an experimental art. Jean Genet claimed that Alberto Giacometti thought that his plaster sculptures lost their provisionality when cast in bronze,[74] and that, therefore, Giacometti painted many of his later bronzes white.[75] Its

[72] "The colour white, since it reflects the greater number of rays, is the one to which the eye is most sensitive, and whiteness therefore, adds to the beauty of a beautiful body: indeed if it is naked, it seems owing to this brilliance to be larger than it is; hence it is that plaster casts taken from statues seem ... to be larger than the originals." Johann Joachim Winkelmann, *Reflections on the Imitations of Greek Works in Painting and Sculpture*.

[73] See erotic fashion photographer Helmut Newton's book, *White Women*, 1976.

[74] Jean Genet, *L'Atelier d'Alberto Giacomett*, 1958.

[76] See also Louise Bourgeois' *Observer*, 1947-49, a bronze sculpture painted white.

identification with secondariness causes white plaster to be read as if a solipsism, a sign for signification itself.

Sitting facing one another at *The Table of Silence* we are attracted by a high-pitched whine, like the sound of bees, or the sound of two-stroke engines. We follow the sound and discover a nearby go-cart track in the *Park of Peace*. Three serious young women are hurling their machines through a slalom series, supervised by a horde of adults who gather on the circumference of the track. We inquire and learn that it is a driver education class.

From Tîrgu Jiu the road climbs north, high into the narrow canyons of the Transylvanian Alps. The Sculptor is driving and, looking down from a switchback, I stare directly into the center of a prison camp. It looks like a movie set from a prisoner-of-war film, the square compound of barbed wire with a watchtower at each corner. Inside the wire are rows of tents, brown canvas separated by stretches of brown mud. Prisoners in striped pyjamas move slowly around the cage. It is a monumental version of the absurd little compound of chicken wire behind the inn at Tîrgu Jiu. With a turn in the road, I am suddenly faced with a sylvan alpine picture postcard scene, and the vision of the camp slips away beneath us.

MY FRIEND, Welcome to the Carpathians, I am anxiously expecting you. Sleep well tonight ... I trust that your journey from London has been a happy one, and that you will enjoy your stay in my beautiful land.
Your friend,
Dracula.[76]

By night we pass through the mountains onto the high plateau of Transylvania. The road is dangerous: Romanians drive at night without headlights and also stop in the middle of the road to sleep.

[76] "Letter in Jonathan Harker's Journal", Bram Stoker, *Dracula.* 1897.

Transylvania (Latin, "beyond the forest") is a treeless steppe surrounded by a blue fringe of forested mountains. I knew this place before as a fictional scene of horror, the stage for Gothic novels. I knew it also as the home of the eccentric Hungarian Baron Nopsca, paleontologist, double-agent spy, self-proclaimed king of Albania, and a suicide. Through his precocious scientific papers, I also knew that the geology of the plateau was similar to that of Western North America with a similar fossil record.[77]

Romanians claim to be the descendents of Romanized native Dacians, and the Romanian language is indeed some form of provincial Latin. If rural Romania seems to be one-half picture postcard and one-half military camp, then here in Transylvania at the archeological site of Sarmizegetusa, the former capital of Dacia, the two are bound close. The Roman amphitheatre, built atop a Dacian sacred site, was once the scene of bloody gladiatorial displays, but now is overgrown with grass, its contours softened. The ruins are mostly concrete, a material that the Romans invented and that the Romanians still use for every conceivable purpose. Many of the Romanian streets and highways are made from concrete rather than asphalt. There is a resemblance between these ruins and the bombed-out look of the new concrete apartment blocks that surround Bucharestii. Aside from the lack of any protruding steel reinforcement, these ruins appear as recent re-creations and the Sculptor believes that some of them are. I am reminded of Albert Speer's architecture and the National Socialist admonishment against the use of steel reinforcing in monumental building construction in order that an attractive ruin be created for future generations: "[using] materials and statics so that they

[77] The Baron developed a theory that the elaborate crests of certain dinosaur species were actually indications of gender and that paleontologists, by failing to distinguish male from female skeletons, had mistakenly doubled the number of species. Taking his cue from the bird kingdom, the Baron assigned the more elaborate crests to the male of the species. Although he was discredited during his lifetime, modern paleontology has tended to confirm many of his theories.

would resemble Roman Models after thousands of years had passed."[78] Here I also recall the entropic ruins of Robert Smithson, and Carl Andre on Robert Smithson: "[his] spirit was aesthetically Catholic and Transylvanian where mine is Protestant and Baltic."[79]

A jet fighter plane flies hawk-like, low over the ruins of Sarmizegetusa. It spouts a rooster tail of orange flame and black, oily smoke. Romania is noticeably polluted, a result of the post-war rush to industrialize, and the paranoiac Cold War decentralization of that industry. Wood smoke from peasant houses mingles with industrial pollution and mountain mist to create a suitably "Transylvanian" theatrical effect.

We drive north across the plateau, past Alba Iulia, and through Cluj-Napoca, sacked by the Mongols under Kadan in 1241, and on into the Maramures depression. Here, where Bukovina, Transylvania and Moldavia conspire together, Bram Stoker placed his fictional Castle of Count Dracula. We are passing through a landscape as if painted by Pieter Brueghel the Elder. The peasant clothing, the tiny straw hats, the wide silver inlaid leather belts, the ornamented leather boots with spiral toes; these costumes change with each valley. The dyed colors of the clothing are bright and odd, magenta and violet, no primary colors, no basic blues or reds to be found here. The houses are massive timber structures with huge yard gates, just like Brancusi's homestead at Hobitza.

At the northernmost point of Romania, on the Galician Ukrainian border near the headwaters of the Tisza River, is the small commune of Sapinta. Here is a graveyard of some 250 wooden crosses, carved and brightly painted, the work of the artist

[78] Robert R. Taylor, *The Word in Stone, The Role of Architecture in National Socialist Ideology*, 1974.

[79] Carl Andre, "Robert Smithson: He Always Reminded Us of the Questions We Ought to Have Asked Ourselves", (May, 1978) *Art in America,* p. 102. Andre has his dichotomous clichés partially confused. The traditional religion of old (Magyar and Saxon) Transylvania is Lutheran Protestantism, just as in Scandinavia, and much of the south coast of the Baltic is traditionally Catholic.

Ion Stan-Patras. The Romanians call it *The Merry Cemetery*. Each grave marker tells the life story of the person buried beneath it through an assemblage of photographs, text, colorful paint and carved wood. A large white rooster patrols the yard. The brightly painted sculpture of *The Merry Cemetery* successfully resolves the syntactical problems I have had with the museum of the living dead in Bucaresti.

Turning east toward Moldavia we cross the Eastern Carpathians by way of the Tartar Pass, the backdoor invasion route of Asia into Europe. At the snow covered summit, we pause balanced between east and west, and consider the orientalist affectations of Brancusi. Sidney Geist discovers meaning in Brancusi through juxtaposition, contrasting Parisian modernism with Romanian primitivism. He admits that Brancusi was aware of the Asian tradition by at least 1924, when he read Jacques Bacot's introduction to *Le Poete Tibetain Milarepa*. Geist suggests that with the large oak carving, *King of Kings* (*Spirit of the Buddha*), 1920, Brancusi "May have attempted a version of the Tibetan Buddhist Stupa (Ch'Orten) …"[80] Both stupa and linga generally correspond to the sequence of forms, the square multi-partite base surmounted by an ovoidal monoform sculpture, typical of work by Brancusi.[81] However, rather than the *stupa*,[82] it is the lingam that seems the most

[80] Geist, *Constantin Brancusi*, p. 102.

[81] Consider Brancusi's phalliform *Bird(s) in Space*, the series of the *Sleeping Muse, Princess X, Torso of a Young Man*, as well as the series of *The Cock*. Brancusi, "I am *The Cock*," Sidney Geist, *Brancusi*, 1968, p. 137.

[82] "Stupa", the Pali "thupa"and the Anglo-Indian "tope", from the Sanskrit *stup*, "to heap"; these from the same Indo-European root as the Greek *stupos*, "stem, stump, block". The stupa is the ubiquitous aniconic monument of Buddhism, historically found as far west as the Volga river in Europe (the Kalmuck Tartars) to Japan and the Phillipines in the east and from Siberia in the north to Java in the south. As a form it is a complex synthesis, derived in various unequal parts from the Kurgan tumulus culture of the Eurasian steppe, the Vedic fire altar, the various serpent and tree cult shrines of Dravidian India, as well as the colonnaded and domed forms of Late Classical, Hellenistic and

appropriate Asian prototype for the sculpture of Brancusi. As a monolithic phalliform representation of Shiva,[83] the lingam is carved square at the base (Brahma), reduced to octagonal at midsection (Vishnu) and rounded at the top (Rudra). These two lower sections are not normally visible, as the whole is set into a socket at the center of the yoni, a libation pedestal that is a representation of the female. When he traveled to India, Brancusi stayed near Ujjain, a center of linga worship. Every stone in the nearby Narmada River is considered to be a lingam, venerated, and sold to tourists priced accordingly.

The plump forms of Brancusi's sculpture were prefigured by medieval period Indian sculpture. In the Indian tradition, rounded

Roman architecture. In its simplest form the stupa is a wooden post (Yasti) around which a mound is heaped. In its fully developed form it consisted of a square or stepped base aligned to the four directions, surmounted by the dome-like mound of the *Anda* (Sanskrit, "egg"). Atop this mound was another square block, the *Harmika,* its form derived from the Iranian/Vedic fire altar. Visible above this (but actually penetrating right through the center of the *Harmika,* the *Anda* and the base) is the shaft of the *Yasti* (Sanskrit, "spine"). Attached to this was a horizontal disk (or a series of disks vertically diminishing in size), the *Chattra* (Sanskrit, "umbrella"), a traditional Indian sign of royalty or divinity. The finial of the *Yasti* consisted of the *Bindu* or "dot". Beneath the base of the *Yasti* there may be a small hidden relic chamber, a *Garbu Griha* (Sanskrit, "seed chamber"). Other than this, the stupa is monolithic. The stupa represents, among other things, the form of the occult human body and the five elements: Earth (the base), Water (the *Anda*), Fire (the *Harmika*), Air (the *Chattra*) and Aether (the *Bindu).* The Tibetan *Ch'Orten,* the *Dagoba* of Sri Lanka, the *Pagoda* of China and the *Tahoto* of Japan are all variations of the Indian stupa, with one or another of the same formal elements emphasized.

[84] Comparative religionist Joseph Campbell identifies Shiva directly with the Egyptian god Ptah, the patron Neter of sculptors, citing numerous correspondences. These correspondences include the various leonine consorts (and vehicles of consorts) of Ptah and Shiva, the Nandi bull of Shiva and the Apis bull of Ptah, Shiva as corpse and Ptah as mummy, and Ptah in his phallic aspect as the fertilizing moonbeam. Joseph Campbell, *The Masks of God: Oriental Mythology*, 1962, pp 90-91.

convexity is understood to represent the inhalation and retention of *prana* (vital breath, a complex conception but not unlike Henri Bergson's *élan vital*.) The upper, rounded glans of the lingam is this conception reduced to Brancusian essential form.

> "(Sculpture should) ... give suddenly, all at once the shock of life, the sensation of breathing."[84]

The wealthy Maharajah of Indore ruled one of the last semi-independent kingdoms in India. The British encouraged him to spend his time in Europe rather than India and there he met Brancusi whom he treated as a guru of sorts. Indore contains an Ashokan period iron pillar similar to the famous rust free forged iron pillar of Old Delhi, but most of the state buildings were commissioned by the Maharajah in European neo-classical style. He commissioned Brancusi to build him a *Temple of Meditation*. However, when Brancusi visited India to begin preliminary work, the Maharajah was busy tiger hunting and they did not meet. Instead, Brancusi made friends with an elephant. Nothing substantial came of the project other than a few sketches and a possible model or two. During his return from India, Brancusi stopped in Egypt to see the Giza pyramids. This was when he predicted that "a great flood" was coming and that sculpture would be "lost in the sands".[85]

British sculptor Anish Kapoor is heir to both the orientalist conceits of Brancusi and the occidentalism of the Maharajah of Indore. His works are charged with references to fecundity and regeneration that range from obvious references to female genitalia, as in *Mother as a Mountain*, 1985, (Gaudier-Brzeska's, "... Sculptural Energy is the Mountain") to subtle identification with female experience: *When I Am Pregnant*, 1992.

[84] Brancusi in Andrei Brezianu, *Brancusi*, 1975.

[85] Constantin Brancusi, "Aphorisms."*Pandrea*, (1945), p. 178.

Correspondingly his male forms are suggestions of ascensional dynamics, the desire for flight, and an aspiration to transcendence. *Pillar of Light*, 1991 is his version of *Endless Column*. Kapoor's *1000 Names*, 1979-1985, refers to the list of Shiva's names, his mountain forms, to Mount Meru/Kailasa, the pillars to the lingam and the voids to the yoni. In the voids is the presence of an absence, a vertiginous centrifugal vortex that is both compelling and fearful, what Vorticist sculptor Gaudier-Brzeska termed, "The Indian ... vortex of blackness and silence".[86]

From the thin cold air of the heights we spiral down the snowy eastern slopes of the Carpathians into the region of Bukovina. Alongside the dirt road stride Paul Bunyan-like bearded lumberjacks with great double-bladed axes. And here is a more familiar religious tradition, that of Eastern Orthodox Christianity, the images of its faith plastered in fresco over the exterior surfaces of the Moldavian churches. In a monastery parking lot, under an "Endless Column" stop sign, a soldier appears to request cigarettes. Nuns show us their treasured icons, covered with hinged relief sculptures of gold and silver plate.

Continuing clockwise, traveling south via Piatra Neamt and Bacau, we cross back into southeast Transylvania near Brasov. We are late trying to reach Castle Bran, first becoming lost in an immense herd of sheep crossing the road, and then are held up at a railway crossing. The wooden barrier is down and a uniformed official stands guard. Although no train is visible across the plain, we must wait nevertheless, secure behind the barricade, pretending that the train runs on time, protected from the danger of its invisible passage. Romanian faith is strong. The faith in the invisible train is like the faith of Christianity (an invisible god), the former faith in Marxist communism (an invisible withering-away of the state) and the enduring faith in vampires (an invisible evil).

[86] Henri Gaudier-Brzeska, "Gaudier-Brzeska Vortex", *Blast*, No. 1, 1914. p. 156.

The lines of vehicles lengthen on both sides of the crossing. The chest of the pompous official inflates with each new arrival. It rapidly deflates, however, with the arrival of two large black government limousines that quickly roar past the line of old trucks, motorcycles with sidecars[87] and horse-drawn wagons. Pairs of Romanian and Vietnamese flags wave merrily from the limousine fenders. The official hustles to raise the barrier but lowers it again after the government officials pass. We must wait. The train comes at last, an ancient Soviet steam engine, like an iron monument to the puffed-up official himself. We drive south to Castle Bran.

On the way south we nearly pass by another castle, this one a ruin atop a small mountain and approachable only on foot. The Sculptor insists that we stop. After a long climb (some 1400 steps) over ramparts that zigzag snakelike up to the summit, we find nothing much except the view of a nuclear reactor cooling tower on the plain below, and in the ruins, one small preserved building of primitive concrete. It contains a single display; a glass box containing a curved steel Hungarian saber, the sword of Vlad Tepes, Dracula. We continue on to Castle Bran.

Built in 1377 as a bastion against the Turks, Castle Bran controls a central mountain pass leading from Transylvania down onto the Danubian plain. Here the people were once mostly imported Saxon Germans, but now are less each year since they have been finally allowed to return to a reunited Germany. Their residence in Transylvania dates from the time of the Turkish depopulation of the area and the subsequent repopulation under

[87] Romanians have the dangerous habit of removing the complete steering mechanism, including the front wheel and the handlebars from the motorcycle and reattaching it to the front of the sidecar. The driver of the motorcycle sits in the sidecar. The passenger sits on the motorcycle seat. Some, more practical persons, leave well enough alone and use the sidecar mostly to haul agricultural produce — red peppers and carrots.

the hegemony of the Austrian Hapsburgs. One of the most notable residents of Castle Bran was Vladimir Tepes, the Count Draculea (Son of the Dragon). His brother, known as the Mad Monk, imprisoned him here. Draculea's cruelties incurred the contempt of his Saxon subjects who avenged themselves by portraying him as a monster in the publications that they circulated in Western Europe. These were the texts used by Bram Stoker as references for his creation of the fictional Szkeley (Transylvanian Hungarian) Vampire, Count Dracula.

Castle Bran is a structure from a fairy tale; all steep walls and slender turrets piled high on the flank of a mountain. It seems heavily restored, invented even, like some of the castles on the Rhine.[88] It recalls two other castles. One I often visited as a child. It looked out over a glacial lake in the Rocky Mountains. It was billed as a "glass castle", but was actually constructed from empty embalming fluid bottles set horizontally into concrete mortar. A local undertaker had built the castle. The other castle was in upstate New York, on a mountain above the Hudson near West Point. This was a cast concrete version of the Alhambra. Still unfinished at the turn of the century, it had fallen into ruin and was purchased by the Dia Art Foundation to be restored as the future home for minimalist sculptor Dan Flavin's Art Institute.[89]

At night we walked around the Dia Castle ruin ... half fallen down, half reconstructed ... it recalled the newly-built ruins of Bucharestii. By flashlight the Sculptor guided me into a small, dungeon-like room deep within the concrete interior. We walked

[88] Robert Taylor, *The Castles of the Rhine, Recreating the Middle Ages in Modern Germany*, 1998.

[89] "Keeping school in a castle is a romantic thing: as romantic as keeping hotel in a castle. By itself the imitation castle is doubtless harmless, and well enough; but as a symbol and breeder and sustainer of maudlin Middle-Age romanticism ... it is necessarily a hurtful thing and a mistake". Mark Twain, *Life on the Mississippi*, 1883, p. 286.

on sharp gravel. In the beam of the flashlight the floor sparkled with light. It was covered with quartz crystals, some natural hexagonal prisms, others cut at eccentric angles; still others had numbers painted on them and inscribed lines. During World War II, the castle was rented to a researcher who ostensibly studied the 4th dimension, time travel and perpetual motion. He cut these quartz crystals for his various mechanisms, for windows and lenses. The sparkling pavement was his waste, the detritus of a crystal sculptor.

Historically the crystalline has been used as a metaphor of lucidity and illumination, but confused with the transparency of glass.[90] Yet the most notable characteristic of the crystalline is not transparency. Rather, it is that inclination of a material to fracture along planar axes that correspond to its molecular structure, each fragment a differential replica of the whole. Recently, the image of the crystal has been used by some sociologists[91] to suggest the complexity of viewpoints on any social phenomenon, as opposed to the single point of view of the gaze, the compensations of binocular vision, and even the very rationally planned triangulated vision of navigation, surveying, and gunnery.

I slept in the Dia Castle and dreamed of *Kristallnacht*: broken window glass fell around me. The triangular shards piled to form hexagonal snowflakes ... bright transparent stars of David, the sculptural ruins of glass architecture.

Our circuit completed, we return to Bucharestii through Sinaia (ski resorts) and Ploiesti (oil refineries). In our absence the capital has been transformed. Before it was alien, but now it has become a friendly place, its urbanity as comfortable and reassuring as an

[90] Rosemarie Haag Bletter, "The Interpretation of the Glass Dream — Expressionist Architecture and the History of the Crystal Metaphor," *Journal of the Society of Architectural Historians*, 1981.

[91] Laurel Richardson, "Writing: A Method of Inquiry," in Norman Denzin and Yvonna Lincoln, *Handbook of Qualitative Research*, 1994.

old armchair. It is a relief to be protected within the anonymous crowd. The curious glances are still there (only *turistica* have cameras) but almost unnoticeable after the inquisitive stares we received in the countryside. We eat a final Romanian meal of *miteti* (sausage-shaped spicy meatballs), with *mamaliga* (corn mush) and *salada assorta* (four different hot pickled peppers), washed down with local red wine, served straight up (the Romanians themselves seem to prefer their red wine mixed 50/50 with Russian-produced Pepsi-Cola).

The Sculptor wants to exchange our train tickets for airline travel. He wants to leave quickly, by plane for Switzerland, but the young woman at Carpatii, the State Tourist Agency, explains that this exchange is not possible. We must take the Orient Express. We need transit visas in order to pass through Hungary. The Hungarian consulate office in Bucharestii is a cube-shaped room with a single interior window opening onto a hidden office. At random intervals a wooden shutter slams open and a claw-like hand reaches out to grab application forms and passports. We stand waiting with a group of African students. They are colorfully dressed in contrast to the drab Romanians. One wears tall snakeskin boots with high heels. They talk to the Sculptor about visiting America. The African students are optimistic, like Brancusi was prior to his departure for Paris in 1903.

The area around the train station hotel smells of darkness and coal. There are peasants piled waiting for trains, literally sitting one upon the other. The hotel bar is filled with drunken government bureaucrats and foreign students. Our English conversation attracts a Nigerian engineering student who wants us to buy him drinks, who wants to tell us of the secret police, of people who disappear in the night and are never heard from again, of the black market; his teeth grinning white rows of Chiclets against the darkness.

Chapter IV
Sculpture on *The Orient Express*

The black iron Russian steam locomotives run on wood taken from cairns piled directly on the tracks. There is no shortage of wood. The Carpathians are sylvan and the atmosphere is clouded with smoke. This Orient Express is actually a local: Bucharesti to Budapest and Vienna, then north of the Alps through Southern Germany to France. The track follows the Danube to its source and beyond, the ancient nomadic Asian migration route into Europe. Brancusi walked this same route to Paris, taking a year to cross the Hungarian Plain (the Alfold) and the German forests to Zurich, collapsing into France at Luneville in 1904.

On the train, in the evening twilight, we pass again through Craiova where Brancusi first attended art school. The local Muzeul del Arta, housed in an ornate Baroque palace, displays his earliest version of *The Kiss* (1907). We pass through the Iron Gate, where the Danube cuts deep through the Carpathian Mountains, now a hydroelectric development, but there is no heat in our sleeping car. The Sculptor (who has insisted on the better bed during all during of our travels) pleads lower back pain and takes the lower bunk. I climb aloft to my bed and relax, then sleep and dream:

The Sculptor asks my help in rescuing Brancusi's three daughters from the barnyard where they are being held captive. When I arrive at the village, the Sculptor and Brancusi are leaning

over a wattle fence, discussing their plan for our rescue of three
young women, who stand nude and transfixed, hands at their
sides, feet together, ankle-deep in the pale mud and manure at the
centre of the enclosure. There is a crude timber-and-sod hut at the
far end of the compound. It is a simple plan. I will fend off the
rooster while they rescue the women. I am amused at their
seriousness until I see the cock. He struts angrily out of the hut and
I am petrified in turn. He is like a small, feathered dinosaur, about
the height of a man, wingless but with the stunted, double-clawed
forearms of a tyrannosaurid and an erect, stiff counterbalancing
shaduck-like tail. His beak clacks automatically on a set of bright
black serrated teeth. A ragged red cockscomb bristles from his
head and continues down his spine. He stalks around the nude
statues, snapping and clawing at them, confident of his control.
We three go over the fence and I manage to pin the cock to the
ground. The Sculptor and Brancusi lead the women away. I am left
alone in the ring with the head of the cock between my legs and
both my hands around his neck, trying to choke the life out of him.
His tail, suddenly serpentine, threatens to pull me backward. I risk
releasing one hand and grab the tail, pulling it off me. As the
cock's jaws come forward to bite me, I push the tail into his mouth
and jump out of the Ouroborus ring.

The Sculptor with his bad back must painfully rise to answer
the door four times at the Hungarian border. The guards are rude
to him, but ignore me in my nest above them. "Welcome to
Magyarorszag (Hungary)". I am asleep again by the time we pass
through Mezaturk on the Tisza river, where my grandfather, Pek
Gabor, had his farm. The Tisza, a tributary of the Danube, is
Hungary's national river although its headwaters near Sapinta and
the Merry Cemetery are now in Romania.

"*A sagittis hungarorum libera nos Domine!*"
— Modena, 924 A.D.

Legend has it that Attila the Hun is buried in the bed of the Tisza,[92] entombed in a coffin of gold (a sign of the tribute of the Western Roman Empire), surrounded by a coffin of silver (the tribute of the Eastern Empire), surrounded in turn by a coffin of carved wood (the tribute of the Goths and the Slavs), all bound in iron (the Huns). The history of the Danube Valley is the history of displaced Asians. Invading Romans were repulsed by the Iranian horse archers, the Jazyges. In the 4th century the Huns were here, herding the defeated eastern Germanic tribes against the Empire. After the death of Attila, the Mongolian Avars ruled for hundreds of years from their mysterious ring citadel, until destroyed by Charlemagne. The Alfold was nearly empty for a time, the *Deserta Avarorum*, and then the Magyars (Hungarians) drifted in from the steppes, conquering the entire plain, the plateau of Transylvania, and all of Croatia to the Adriatic Sea. They raided Europe as far as Paris for a century. In 1241, the Mongols of Batu Khan harvested Hungary and Romania for one long summer. Cuman Tartar tribes repopulated the Alfold along the Tisza.[93] Waiting in the queue of invaders were Turkic tribes, displaced from Turkestan by this same Mongol expansion and bottled up on the Anatolian peninsula by the Byzantine Greeks. After the fall of Constantinople they tramped up the Danube several times, banging at the gates of Vienna in 1529 and again in 1683. The latest eastern invasion of the Hungarian plain came in 1945. Hungarians are Slavophobic and this century have joined with Germany twice in misadventures against the east, and have twice shared in the consequences of defeat. Until recently, six Russian motorized cavalry divisions occupied Hungary.

[92] A similar burial is claimed in Italy for Alaric, King of the Visigoths. There may be some confusion between the two legends. Neither burial has been located.

[93] A move financed by the sale of half of the tribe's warriors into Muslim slavery, to become the famous Mameluke "slave dynasty" of Egypt.

According to discredited Soviet linguists, Hungarian origins lay in Soviet Western Siberia. But recent archeological evidence (and a surviving relict population) point to Hungarian origins in Sinkiang, that area of western China sandwiched between Tibet and Mongolia. Unorthodox linguists have proposed ancient Sumeria as the earliest Hungarian homeland, for Magyar legend claims the Biblical Nimrud, the builder of the Tower of Babel, as ancestor. According to legend, Nimrud had two sons, Hunnor and Magor, who pursued a golden stag over the mountains to the north where they stole wives from the giants and fathered two tribes, the Huns and the Magyars. This legendary relationship between Hun and Magyar is used to rationalize Hungarian land claims against Romania (which occupies ethnically Hungarian Transylvania), a claim the Hungarians date to the 5th century Hunnic occupation and the 9th century Magyar "reoccupation".

In attempting to distinguish between the various nomadic Asian tribes invading Europe, recall that these peoples made no very great distinctions between themselves. The hordes were loose, often seasonal coalitions of common purpose, not nation states. Names of tribes changed with individual rulers. Yet the steppe nomadic culture was remarkably homogeneous throughout its huge range. From Central Europe to Korea, there was once a single polyethnic culture, characterized by the arts of horsemanship and archery, the architecture of the yurt, the drinking of *kumiss* (fermented mare's milk), and the proto-religion of shamanism. Iron working is intimately related to Central Asian shamanism and the occupation of the metalsmith was often the basis of a rise to power. The Mongol warrior Temujin ("blacksmith") became Genghis Khan.[94]

Brancusi was no heir to these eastern robber bands. Rather, he was a citizen of Wallachia, that region of Romania bound on the east by the Black Sea steppe of Debruja, on the west by Hungary

[94] Deleuze, Gilles and Felix Guattari. *Nomadology: The War Machine*, 1986.

and the Iron Gate, south of the Transylvanian Alps and north of the Danube. The original Celto-Thracian inhabitants of this region, the Dacians, were conquered by Rome (an event memorialized in Trajans Column. There is a full size plaster cast of the column in Bucharestii). A century later the colony was abandoned and the Romanized Dacians disappeared from history until the 12th century, when they reappeared as the Wallachians, invading the Carpathian region under their ruler, Radu the Black. Romanians claim that the historical gap in their occupation of the land (particularly Transylvania) is nothing more than the unfortunate consequence of the 13th century Mongol invasions when many written records were destroyed.

"... for more than a thousand years, barbarians came through our land, killing and burning ... our people were obliged to take refuge in the forests ... they had to stay in the forests for a long time and learn to make everything they needed out of wood ..."[95]

It is likely that the Wallachians survived the eight centuries between Trajan and Radu by hiding somewhere in the dense Balkan forests south of the Danube. Other Vlachs still live today in remote regions of Greece, and speak the same Latin dialect as the Romanians. The Wallachians were a pastoral people, shepherds, semi-nomadic but pedestrian, culturally Mediterranean rather than Central Asian. Brancusi walked to Paris; he did not ride. The modern myth of Brancusi as heroic folk carver is to be understood within the context of Romanian nationalism, the legend of "survival through woodworking", and within the politics of the conflicting Hungarian (Magyar) and Romanian (Wallachian) land claims to the same Transylvanian basin.

[95] Romanian Woodcarver Dumitru Balaci in W.S. Ellis, "Romania, Maverick on a Tightrope", *National Geographic*, November, 1975.

I wake from my dreams of history to find *The Orient Express* still slowly snaking across the plain of the Alfold. It is a flat, treeless pasture. I know that it is actually a basin like Transylvania, with mountains forming the rim of the cup, but from the train there is nothing on the horizon, North Dakota. There are some cattle and herdsmen on horses. And here also are the huge counterbalanced trees, the *shadduck* wells that I first saw in Romania. The trees come from far away to be erected in this empty place. I pace in the corridor, as I think of Brancusi walking across this plain. I also recall the story of the 19th century Hungarian linguist who walked all the way to Tibet in search of the proto-Hungarian homeland, the stories of the impoverished American settler who pushed a wheelbarrow the entire 2000-mile-length of the Oregon Trail, and the Polish military officer who, imprisoned in Soviet Siberia during WWII, escaped to walk south across Siberia, Sinkiang and Tibet to freedom in British India.[96] But mostly I think of poor Czaky, the Hungarian Cubist sculptor. He walked to Paris just a few years after Brancusi, and socialized with very nearly the same circle of artists. He produced several seminal works of cubist sculpture. However, during the First World War, Czaky joined the Austro-Hungarian military on the losing side of the conflict. After the war, upon his return to Paris he found his work destroyed and his contribution to modernism apparently deliberately forgotten. He immigrated to America where he slipped steadily into obscurity. In New York his sculpture was limited to the production of art deco home furnishings. At his death, a hat was passed around to pay for a retrospective exhibition catalogue.

Brancusi travelled the plain by night, like an escaping convict, for fear of the Magyars. To the Wallachian forester, this open bare steppe was an endless horror. Here Brancusi always wore his black bourgeois suit. Once past Vienna he could change back into

[96] Rawiez, Slavomir. *The Long Walk*, 1956.

his peasant clothes, but here on the Alfold it was not safe to play the rustic Vlach.

The Sculptor has not been interested in the view from our window, but has tried to sleep, wrestling with his bad back. He wakes as we pass through Budapest, close under the fortress walls of old Buda. We are approaching the ruins of the Iron Curtain. *The Orient Express* slowly crawls through a loosely strung fence of barbed wire. In the distance, across the old minefields, is another fence, the Austrian border. There is a customs check when the train stops, but my bags remain unopened since Bucharesti. The sound begins behind us, like distant thunder, a booming like the sound of heavy dungeon gates closing, a sound effect from a Frankenstein movie. It is repeated again and again, closer each time, like many doors slamming on a hallway. I see a uniformed man on either side of the track, each one holding an end of a long iron bar that passes entirely under the width of the coach. At intervals of every few meters they slam the bar up into the undercarriage. They do this for the entire length of the train. We then pass out of this zone and through a taut wire fence into Austria. I find out only later that the ritual of the iron bar is an attempt to dislodge refugees from the east who may be concealed beneath the train cars. Our transition from east to west is a memory of the iron curtain, now only a curtain of sound, the sound of blacksmithing, the echoes of Joe Steel, Joseph Stalin.

If Romania is an *Animal Farm* and Hungary a steppe haunted by ghost riders, then Austria is simply clean and neat. Contented Mercedes sleep in front of prosperous suburban houses. Only in the outskirts of Vienna does it change, as we slowly pass through the open wounds of large industrial complexes, past cluttered loading docks and filthy scrap yards. At Vienna we stumble sleepily around on the large concrete station platforms. The trains all change here between impoverished east and prosperous west. We seek and find another train marked Orient Express. The conductor also changes. Whereas before he was a short, grey-haired and mildly inefficient Romanian, now he has become a tall,

young and blonde German in a neat uniform. Here in Austria, Brancusi also changed, from his black suit into his Wallachian peasant costume. Here again were his secure forests and now he confidently walked by day. The mountain Austrians have preserved their carving traditions, but Brancusi travelled low along the Danube where the international influence of Vienna had replaced such things. He entered Western Europe content in his conceit that only Romanians knew how to carve wood.

After Vienna there is no sleeping car and we settle comfortably into an empty first class compartment. The Sculptor insists that we find one to ourselves so that he can lie across several seats to ease his painful back. Ours is the last compartment of the first class carriages. Behind us is the crowded second class car. We lounge on the seats, facing one another. The new conductor orders me to remove my shoes from the seat. We are hungry but the dining car is closed.

Just before dark, the Turks invade from the second class car. Beyond Vienna at last, these are European "guest workers," men, women and children with all their possessions jangling together in a single large burlap sack. They smell bad, and cough constantly. The Sculptor and I are squeezed up against the window. The old man of the group introduces himself by jabbing a thumb at his chest and crying, "Toork, Toork." The Sculptor replies with a plaintive, "Mercan, Mercan." The old Turk nods wisely, content in his nomadic superiority to the merchant that he sees before him. The Sculptor wants to lie down and impatiently fetches the new conductor who, with all the authority of a Medieval Landsknecht defending the walls of Christendom, sends the Turks scuttling back to second class. He then departs with a crisp nod to the Sculptor. Within minutes of his leaving, the Turks attack again, but only the men this time. The conductor returns on his own initiative and again forces the Turks back. They leave slowly, begrudgingly this time, each pausing to stare intently at the Sculptor, who sprawls in guilty first class comfort.

With the darkness a single Turk returns, a young man. As he attempts to open our compartment door, I hold and then close it on him, obeying the instructions of my travelling companion. The Turk retreats a few steps into the hallway grabbing for a knife under his dingy sports jacket. He remains in the hallway, one hand on the handle of his knife, posed like an impoverished Napoleon, staring through the glass at the Sculptor. I sit beside the door, watching the Turk for several hours until somewhere in the German darkness he disappears. The battle is won but the war is lost, for when the Sculptor returns from a long delayed visit to the washroom he finds a French businessman sprawled sleeping across all of his former seats. I dream, sleeping comfortably propped against my companion, as he stares painfully awake into the darkness.

"What devil or witch was ever so great as Attila, whose blood is in these veins?"[97]

The European Huns were likely one remnant of the Hsiung-Nu who, after the destruction of their empire by the Tang Chinese,[98] migrated west from Mongolia. They raided both the Eastern and the Western Roman Empire from their base on the Tisza River in Hungary until checked near Paris in the Battle of Chalons. Hunnic migration patterns are traced through finds of their large bronze cooking pots. These vessels look like looted oriental temple bells,

[97] Count Dracula in Bram Stoker, *Dracula,* 1897.

[98] During the 4th century the majority of the Huns moved west to invade first the Middle East, and then Europe. Others turned south. These Ephthalites or "White Huns" destroyed the Gandharan Buddhist kingdoms of what are now Pakistan and Afghanistan. Others possibly fled east, first to Korea (the Silla Culture) and then to Japan where they dominated the late Kofun culture and layed the militaristic and equestrian foundations of the Samurai class. The typically asymmetric Hunnic bow survives today in Japanese traditional archery.

but upended for cooking. According to the Romans, Attila died while deep in his cups, choking to death on his own blood from a nosebleed suffered while in a drunken slumber. That drunkenness followed upon his wedding to Ildico (Hilda ... but according to Northern European legend[99] he marries Gudrun and is her victim by murder.) When he died, the Huns, instead of shedding tears, slashed their faces in mourning, fought among themselves as well as with their Ostrogothic German (Hilda and Gudrun) underclass, and their empire collapsed.

When I think of Attila, I think of Brancusi, for although immortalized in his rapacious aspect as the Atli of the *Volsunga Saga,* Attila's public manner was restrained. Witness the narrative of the embassy sent in 449CE to Attila by Theodosius the Younger, Emperor of the East:

"(while) ... the guests drank from cups of gold and silver, Attila had only a wooden cup ... his clothes were distinguished from those of other barbarians because they were one colour, and without ornaments, his sword, the chords of his shoes, the reins of his horse, were not as those of other Scythians decorated with plates of gold or precious stones."[100]

Attila's single wooden cup of ivy wood was like an Asian monk's begging bowl. He came begging, extorting, to Europe. He invaded Gaul in disagreement with his childhood friend Aetius, by then a Roman general, over the ownership of some golden bowls. With the Huns came the Central Asian tradition of the skull cup. The drinking cup of the Khan of the Bulgars, a Hunnic tribe, was made from the cranium of a defeated Byzantine Emperor.

[99] The *Volsunga Saga.*

[100] Gibbon, Edward. *The History of the Decline and Fall of the Roman Empire,* 1783.

"Kurya, Lord of the Petchenegs attacked. They killed Svyatoslav, made a cup from his skull and drank from it."[101]

Consider *The Cup*(s) of Brancusi, the three woodcarvings of 1918. Brancusi's radical simplicity, his essentialist mysticism, his aping of the Buddhist poet-monk Milarepa, is well known. And although Priscus claims that Attila was exceedingly arrogant as well as simple in manner, the same claim has been made of Brancusi. Affectations of extreme simplicity set one apart, secure from contact with ordinary, complex pleasures. Simplicity is related to the sacrifices of leadership, to martyrdom and to the psychology of masochism. Temper the ferocious Attila with knowledge of his simplicity and temper Brancusi's legendary simplicity with knowledge of his complex ordinariness, his abuse of alcohol and nicotine,[102] and his irascible personality.[103]

Like Brancusi with his *The Cock* and *Bird in Space*, Attila also had his bird, his totem goshawk.[104] Unlike most raptorial birds, the goshawk is a forest hunter, preying on rodents, voles and squirrels. The remote valleys of the Carpathians are even today like the compartments of a vast ethnographic museum, filled with human sweepings from the plains below. The Wallachian squirrel-like concealment in the wood and the swift violent harrying of that

[101] Rudolph Poertner, *The Vikings, The Rise and Fall of the Norse Sea Kings*, 1971.

[102] Sidney Geist claims that Brancusi had an "excessive" taste for wine, "smoked ceaselessly", and "eventually had to be treated for nicotine poisoning". Sidney Geist, *Brancusi, A Study of the Sculpture*, 1968, p. 8.

[103] As evidence of this irascibility consider Brancusi's inappropriate praise for Adolf Hitler in post-1945 Paris, noted by the Romanian playwright Eugene Ionescu.

[104] "Attilae Hunnorum Regi hominum truculentissimo qui flagellum Dei dictus fuit, ita placuit Astur, ut in insignia, galea, & pileo eum coronatum gestaret" — Aldrovandus in T.H. White, *The Goshawk*, 1951

concealment by Hun and Magyar is the rhythm of Eastern Europe, a conflict that has hardened into myth. (Arriving as they did in the war-wasted Deserta Avarorum, it is appropriate that the ruling Arpad Dynasty of the Magyars had as its emblem the strutting carrion crow. In 1368, the Ottoman Turks defeated these same Hungarians (and their Serbian allies) at Kossovo, the "field of blackbirds.")

I wake from my dreams of Attila to find us pulling into the Gar du Nord. We rush hungrily across Paris to a small hotel where the owner insists that we crane our necks out the window to view the Louvre at the end of the street before we can eat. The Sculptor is tired. I don't think that he has really slept for the last two days. We cross the Seine to visit Brancusi's studio now preserved at the Centre Georges Pompidou. The studio is dank with the smell of wood mould, like a forest or a hayloft in an old barn. The skylights do not actually open to the sun and the artificial lighting does not evaporate the decay, that subtle rot common to museums and tombs.

The first impression of the work in the studio, the sculpture proper, as well as the bases and the furniture, is that it is not at all like Romanian folk carving, the frantic gnawing with which we became so familiar in past weeks. Our relatively rapid train travel has allowed us the luxury of comparison, but Brancusi travelled slowly. I have had the opportunity to dream only twice since Bucharesti, but Brancusi travelled for a year, gazing at steppes and forested mountain landscapes, remembering and forgetting, imagining and dreaming. When Wallachian folk carving appears in his work, it is generalized, a generic or abstracted copy of Romanian folk carving. Along with the forgotten Czaky, the remembered Lipchitz, Archipenko, and Zadkine, Brancusi brought the geometric patterns of Eastern European folk art to Western Europe, where it was seminal to Cubist Modernism.

All of Brancusi's sculpture is smaller than expected. Museum photographs predictably emphasize the object as an object. After all, museums are still in the business of hoarding objects. Brancusi's

own photography of his sculpture is very much the opposite, revealing his sculpture as ethereal form disintegrating in light, like the body of a vampire exposed to the sun.[105] Some few of his photographs are displayed here, but the albums are opened to only a few selected pages and are displayed under glass where the reflected light makes them difficult to see, like Charles R. Knight's paintings in the American Museum of Natural History in New York. Instead we see our own reflected faces.

Rodin's estate in Paris preserves thousands of photographs commissioned by the sculptor. As well as forming a thorough documentation of Rodin's sculpture, they comprise the early history of photographic technology, from daguerreotypes through to gelatin silver prints.[106] Historically, photography and sculpture have been close, sharing dissimilar but equally complex technical practices. After one of Brancusi's self portrait photographs was altered (by placing his bulb shutter release hand over his crotch) and published without his permission, Brancusi abandoned photography.[107]

Nearly lost among the sculptures in Brancusi's studio is a small painting of birds in flight, long white triangles against a bright blue sky, like the conventional representations of UFOs.[108] There are the large final plaster versions of *The Cock*, a backroom filled with plaster moulds, both hand and motorized tools (of which no real catalogue exists), a dusty set of golf clubs, a violin, a small forge and a pile of blacksmithing tools.

[105] Brancusi in 1948, "Mais la sculpture, c'est de l'eau, de l'eau." Sidney Geist, *Brancusi, A Study of the Sculpture*, 1968, p. 164.

[106] Rodin was born in 1840, just one year after the birth of photography.

[107] John Ruskin thought photography useless for the documentation of sculpture proper, suitable only for the depiction of coinage. Yet, as sculpture has become coinage, eclipsed by the convenient paper art currency of photography ... so Ruskin's insight is humorously redeemed. John Ruskin, *Aratra Pentelici, Seven Lectures on the Elements of Sculpture*, 1892, p. XV

[108] *Birds in the Sky*, watercolor and gouache on paper, 1930-36.

Brancusi kept a ceramic vase stuffed with money at the center of the large central table in his studio. He called it his "bank". The day that Brancusi died, the vase disappeared.[109] But his other cornucopia, *The Cup*, is still here in several versions. It is a solid wooden hemisphere, ten inches across in an early work and twice that in a later version. It recalls Eastern European folk carving, the carved wooden ladles and bowls, but does not function as a container. Instead, it is full of itself, a dense hardwood monolith without hollows. It recalls the monolithic Kalasha vase finial of the Hindu temple that represents a cup full of resonance or aether. As a representation of the expectant and the expansive, *The Cup* is unreasonable, a mythical or unrealizable vision of an impossibly full and complete future.

(Elsewhere in the museum an exhibition occupies two rooms of equal dimensions, each room with an entrance onto the same hallway. Another door joins the two rooms together. In the center of one room is a pair of concrete blocks, standard commercial solids, placed side-by-side, horizontal and parallel to the walls of the room. The blocks seem an obvious representation of the enclosing rooms, reduced in scale and topologically inverted from hollow to positive. The other of the two parallel rooms is empty, yet full of its own representation next door: empty yet full of itself.)

The Sculptor seems very disappointed that Brancusi's sculpture looks so little like Romanian folk art and suddenly thirsty, leaves to find a drink of water. Alone in the studio, I lift one *Cup*. It is set at shoulder height like a head atop an E*ndless Column*-type base. It is heavier than I expect it to be. Here also is the second version of Brancusi's *Sculpture for the Blind* (onyx, 1925). It is small, approximately the size of a human head, about a foot long and strangely flattened, elliptical in cross-section rather than round like the earlier version. It looks like someone has sat on it. I slightly

[109] From a personal conversation with James Johnson Sweeney after his lecture to the Brancusi Symposium at Fordham University in 1975.

close my eyes as I rub it, feeling the subtle crystalline facets on its surface. ("… an egg where little cubes seethe, a human skull."[110])

Brancusi's *Sculpture for the Blind* reminds me of another, a miniature steel Alexander Calder sculpture just outside the front door of the Hirshorn Museum in Washington, DC. It is a replica of the huge steel *stabile* sculpture next to it. The rivets used in the construction of the large sculpture are the same ones used in the miniature. A small plaque in Braille explains that this small sculpture, studded with the now huge, out of scale rivets, is intended to allow the blind to participate in the experience of viewing the huge Calder sculpture.

I rub open my eyes to find myself staring into the face of a well-dressed woman sitting on a bench in Brancusi's studio. She doesn't move, but sits watching me. As she stands to greet two others, I realize, almost too late, that she is a museum guard. They all carry large white purses, ignore me, and secretively smoke cigarettes.[111] Walking away, I think of Attila's simple wooden cup and recall that Brancusi sometimes referred to *Cup II* (1917-1918), as *The Cup of Socrates*. It was an oak carved representation of a vessel filled right to the brim, not with aether or resonance but with poison hemlock. Brancusi referred to his friend, the Scotch-French composer Eric Satie[112] as "Socrates".[113] The smouldering guard women recall the murderous Hilda and Gudren.

[110] Brancusi in Sidney Geist, *Brancusi, A Study of the Sculpture*, 1968, p. 57

[111] Later, I see these same furtive smokers rapidly extinguish their cigarettes when Mdme. Pompidou, makes an unexpected visit to the museum. They rush from room to room, warning others with the bird-like cry of, "Pompidou, Pompidou."

[112] Satie's *Socrate*, "… as white and pure as Antiquity."

[113] The Ancient Greek philosopher Socrates was the son of the sculptor Sophroniscus. Socrates referred to Daedalus (the mythical founder of sculpture, supposed inventor of the lost wax bronze casting process and the builder of the Minotaur's maze) as his ancestor. As a young man, during the reign of Pericles, Socrates was employed on the carving of the draped figures of the *Graces* on the Acropolis.

The Sculptor temporarily leaves. He flies alone to Sweden. From the Carpathians he restlessly dreamed of the Swiss Alps and from Paris he dreamed of Gothenburg. The hotel moves me into a single room on the rooftop with the pigeons. Alone, I wander around Paris; buy some cheese and visit an exhibition of gold at the Grand Palais, nomadic Scythian Art from the hoard in the Hermitage at St. Petersburg. After Transylvania, the Parisian streets are as common as New York. I see a recording of Romanian folk music in a store window. On the record jacket is a photograph of Brancusi's *Table of Silence*.[116]

Near the Gar du Nord train station, I walk a narrow street lined with dark doorways, each illuminated by a pale woman. Each is *essuyait let plâtres;* plastered with white makeup, adding age to youthful faces and youth to aged ones. Eyelids are painted bruised purple, lips bloody red. As I pass, some whisper special services and prices, but most just grin as they quickly open and close their fur coats to reveal brief glimpses of white torsos, forms truncated by stockings and defined by the complex bindings of lingerie.[115] One woman wears an hexagonally patterned scrim fabric stretched over her face, a veil that vibrates with changing diffraction patterns as I pass. These women don't walk the street, but pose in their niches as if statuary, each one a shivering, worn, white plaster Galatea.

"The more you fail, the more you succeed. It is when everything is lost and — instead of giving up — you go on, that you experience the momentary prospect of some

[114] Brancusi's own music, a CD with selections from his record collection, is offered for sale at the Centre Georges Pompidou. It is an improbable medley ranging from *Gold Diggers of 1933* and Louis Armstrong's *Squeeze Me*, to Bartok, Stravinsky and, of course, Eric Satie.

[115] "It is not the classical statue, but the classical torso that we really love", Oswald Spengler, *The Decline of the West, Vol. 1: Form and Actuality*, 1918 (Oxford, 1991) p. 134.

slight progress. Suddenly you have the feeling — be it an illusion or not — that something new has opened up."

— Alberto Giacometti[116]

"I admire the critical distance it takes to reduce a problem to a point where an invention occurs, where the language changes. It is thought that accounts for the invention, for the fact that the language has changed ..."

— Richard Serra (on Alberto Giacometti)[117]

Parisian (Protestant Italian-Swiss) sculptor Alberto Giacometti's sculpture program was an obsessive and a very nearly deliberately futile attempt to represent the visual space that surrounded and compressed a figure. It determined that his work remained necessarily incomplete.[118] It was a program suitable to the secondariness of plaster. According to composer Igor Stravinsky, Giacometti claimed that, "Brancusi wasn't a sculptor at all ... [only a] maker of objects ... [and that] men in the street walking in different directions are not objects in space."[119] Giacometti painted several later bronzes white, ostensibly in order to regain his conception of sculpture as a provisional plaster study of spatial dynamics (the "walking in different directions").

But it is only Giacometti's male figures that are depicted in motion. Only the men are out street walking, posed with their feet apart. Giacometti contradicted his own claims for sculpture with

[116] Alberto Giacometti in Jacques Dupin, *Alberto Giacometti*, film by Ernst Scheidegger and Peter Münger, (autumn 1965), 1966, Serra.

[117] Richard Serra, *Richard Serra Sculpture 1985-1998*, 1999, p. 192.

[118] Few pieces would likely have survived at all if not for the efforts of his brother Diego, who was responsible for casting in bronze the clay and plaster sculpture that Alberto temporarily abandoned.

[119] Igor Stravinsky, "Stravinsky as Seen by Giacometti — Giacometti as Seen by Stravinsky." *Vogue* (New York), (15 August, 1958), pp. 82.

his representations of standing women. He hired prostitutes as models. They stood at a specified distance from him, a distance he had marked on his studio floor. Posed as if bound, feet together, nude and unmoving, they were paid to converse with Giacometti as he worked, with only their mouths animated.[120] (The immediacy of photography, then film and now video, has freed the model from this traditional bondage, freezing the spectator instead.)

The use of frozen prostitutes as models for plaster sculpture reveals another source for Giacometti's white painted bronzes. *Filles de plâtre*, the "plaster women", is a late 19th century term that referred to the Parisian prostitutes living temporarily in newly renovated apartments. Men would rent these apartments at very low cost during the long period of time that the freshly plastered walls took to dry. These men and their kept women appeared on the streets of Paris with their clothing smeared with plaster. Giacometti's sculptures of women were images of the *filles de plâtre de Paris*, the women of plaster of Paris.[121]

Near the end of the street of plaster women, is a small store that sells only knives. There is kitchen cutlery, and there are stainless steel switchblades and Scandinavian hunting knives, but for my new travelling companion I choose a modest French Opinel. It is an alpine lock knife with a carbon steel blade and a simple varnished wooden handle. I am hungry and want to carve my cheese. When I first saw Brancusi's sculpture in the late 1960s it reminded me of carved cheese, like the sickle moon. (The Sculptor once proposed to carve the moon into a permanent crescent.) I also purchase a small white square of fine, hard stone and sit down on

[120] Yet, for all this (economic and other) bondage, several women of my acquaintance claim a great affection for the sculpture of Giacometti, just as to the opposite and equal degree that men of my acquaintance affect to despise it. Richard Serra is an exception to this general rule; early in his career he studied the work of Giacometti in Paris for several months in the mid-1960s.

[121] Philippe Hamon, Chapter III, "Plaster, Plate and Platitudes", *Expositions*, 1992 p. 140.

a bench outside the store to sharpen the knife. Using saliva for a lubricant, I repeatedly stroke the knife over the surface of the stone, the blade angled at only a few degrees, as if cutting off a thin layer of the stone, slowly carving the stone as I quickly sharpen the knife.

The production of sculpture involves repetitive labour.[122] Repetition can be understood within a gendered history of labour. Although the constantly repeated touch is generally considered a characteristic of traditional women's work (for example, the construction techniques of weaving),[123] *taille direct* carving is also repetitive work. During the past century carving had been claimed by an atavistic reductivist ideology: a quasi-masturbatory sublimation of the Neolithic tool making process, traditional men's work. Compare the sharp edge of a knife or a chisel with the extreme surface or edge of an object by Brancusi.

Contemporary women's sculpture is often technologically and formally anachronistic, but only within the context of the "nothing is new" homily that nearly terminally afflicts the history of (men's) sculpture. Women now come to sculpture, and to sculpture courses in colleges and art schools, relatively free from the prejudices that have formed it over the course of the previous century and now pursue the material in art with a vengeance wrought by a historically denied access. Women's sculpture re-explores numerous nearly abandoned technical and formal conventions, including mould making, stone carving, metal casting, and the use of the pedestal. In women's sculpture, familiar paths

[122] Brancusi: "Work is a Biblical curse" and "A sculptors toil is slow and solitary", Geist, *Brancusi*, 1968, pp. 143, 166.

[123] Relatively portable, repetitive, multipartite sculpture is most characteristic of the traditional art of nomads (for instance, Scytho-Siberian objects in the "Animal Style") and was produced by an artistic underclass. In Eurasia this underclass over time slowly became composed nearly exclusively of women and it is women's domestic crafts that survived to dominate traditional nomadic art production to this day.

are inevitably followed but not necessarily in previous footsteps or following the same set of signs.

I recall that not all of the sculptures in Brancusi's studio were as smooth as their photographic images. *Sculpture for the Blind*, had subtle texture. The fine parallel lines of the claw chisel were not completely erased by polishing. Those carved surfaces were not reductive but were constructive of images. The faint tool marks looked like the feathers of birds. These and the occasional broken edges made the sculptures seem like birds with clipped wings, sculpture grounded in 20th century materialism. Perhaps sculpture sank to this, as it fell materially from the light of stars. The sadness of sculpture seems in its material, the gravity of fallen stars.[124]

I take my sharp, new companion for a walk to the Cimetière Montparnasse to see if we can find the grave of Tatiana Rachewsky,[125] but we get totally lost and instead find ourselves at the zoo in the Jardin des Plantes. We see Siberian tigers in a tall circular cage built like a carousel around a small mountain of stone. They leap around and around the cage, threatening to turn into butter.

The French Romantic sculptor Antoine-Louis Barye represented wild animals in combat.[126] He had undertaken a scientific study of animals at the Paris Zoo that coincided with a growing interest in natural history, among scientists, writers and artists and also eventually among the general public. Barye originally exhibited animal sculpture at the Salons of the 1830s

[124] Consider the minerals that fell from heaven. There is a long history to the veneration of fallen objects: the Ben stones of Ancient Egypt, the meteoric cornerstone of the Kaaba at Mecca, the Vajra (adamantine thunderbolt) of Tantrism and the stone Mjøllnir (Thor's Hammer) of Norse mythology.

[125] Her tombstone is the only full body version of Brancusi's *The Kiss*, 1910. The couple are represented in coitus, the legs of the woman embracing that of the man.

[126] *Jaguar Devouring a Hare*, bronze, 1850.

but his work was somewhat marginalised in relationship to statuary proper. However, he did inspire a school of French animal sculptors known as *Les Animaliers*, the best known of whom was Pierre-Jules Mene, who specialized in appropriately small-scale cabinet sculpture representations of domestic animals.

Les Animaliers were part of the collaboration between artists and natural scientists that developed from the Renaissance through to the invention of photography. As the natural history painters were attracted to the colours of tropical shells and the complex transparencies of mineral crystals,[127] so sculptors too were attracted to these frozen geometries, but also and ironically, to animals. (Animals move, are literally "animate".) In the case of painting the collaboration with science dissolved with the invention of photography. However, sculpture as a technology, particularly the use of moulds and casts, survived as an aspect of the excavative, preservative and restorative technologies associated with archaeology and paleontology.

The sculpture of animals was significant to the success of the early modernist agenda. Abstraction was initially more readily accepted in the representation of animals. As early as the Old Kingdom of Egypt, the sculptor of animals was allowed a greater degree of freedom (in that case a freedom to depict animals realistically), denied to representations of human form. Early modernist sculptors such as Henri Gaudier-Brzeska (*Birds Erect*, 1914), Raymond Duchamp-Villon (*Horse*, 1914), as well as Constantin Brancusi (*Bird*, 1915) appropriated the marginal status of the animalier.[128] Brancusi's reductive sculptures of fish, seals, penguins, and tortoises, have their sources in his photography[129] done at the Paris Zoo, done in the footsteps of Barye.

[127] For example, Leroy de Bard's *Minerals in Crystallization*, painted in 1813, exhibited at the salon of 1817.

[128] Alberto Giacometti's sculpture of a starving dog, *La Chien*, 1956, is a faint anorexic and parodic echo of this early modernist affectation.

[129] Produced under the direction of his friend, the photographer Man Ray.

On the beach near Nice in 1924, Brancusi built a *Temple of the Crocodile* out of driftwood, a predecessor to his *Ansamblul de la Tîrgu Jiu*. The crocodile temple at the Paris zoo is a long concrete barn divided into stalls with a walkway along one side, like a train coach. It smells sweetly bad, like natural gas or rotting meat. There are different types of crocodilians in each stall compartment. There are slim Gharials from the Ganges, slinky Black Caymans from Paraguay, both the rare Chinese and the common American alligators, large Nile crocodiles from Africa. They don't move much. They smile as if they have something better to do than move. They are like sculpture, impossibly patient, waiting. Farther down the hallway, the reptile house branches into an aviary with cages of chicken wire mesh. There are hawks, owls, Indian jungle fowl, and one large strutting beast, apparently out of evolutionary sequence, more dinosaur than bird.

At the end of the hallway, the building is already partly rubble, threatening to collapse. It doesn't feel safe. For reassurance, I touch my stiff little travelling companion inside my coat. There are iron-barred cages along this corridor. The Barbarians are displayed here, but all mixed up, not neatly segregated by species. There are 5th century Ostrogoths mixed in with 15th century Turks, steppe Mongols sharing cells with seafaring Baltic Vandals. Red Army Cossacks share a compartment with the Totenkampf SS. A Cuman Tartar and a Golden Scythian sit plotting their escape across the thousand years of history that separate them.

The very last compartment on the hallway has only two occupants, a squinting Hunnic Magyar and a bearded Wallachian. They sit facing one another from opposite benches, arguing over the possession of the old wooden bowl that they must share between them, this lost treasure of Attila and Brancusi. I try to enter the compartment but the Magyar stands and blocks my way, shutting the iron bars of the cell against me. I reach for my knife but my travelling companion has turned into a pen.

Chapter V
Henry Moore in the Pub

As Paris is built upon a great mound of gypsum that has been mined for centuries,[130] so England seems to be built atop white chalk.[131] From the Calais ferry, the chalk cliffs of Dover flash white through the fog. A gigantic reclining figure is revealed in these exposed bare cliffs, the ghost of a sculpture by Henry Moore, an erotic geologic Albion.[132]

We are driving north from London on the M-1. The Sculptor is tired and hungry. She needs to eat. She needs a drink. She needs a pill. Her whining pulls us off onto a small, cobbled, country road and into a well-preserved rustic village. There are signs of conservation everywhere, old buildings and petrified tree stumps. In fact nearly every commemorative bronze plaque in the village

[130] Hence the term "plaster of Paris". When their sharp angles are slightly rounded, arrowhead-like twinned crystals (selenites) of gypsum are referred to as "Montmartre Twins", after their type location in Paris.

[131] Chalk ($CaCo_3$) is older, harder, than gypsum ($CaSo_4$). It is calcium carbonate, a fossil stone derived from the calcite exoskeletons of prehistoric invertebrates.

[132] "… where the garment gapes … it is intermittence, as psychoanalysis has so rightly stated, which is erotic: the intermittence of skin flashing between two articles of clothing, between two edges: it is the flash itself which seduces …"
— Roland Barthes, *The Pleasure of the Text*, 1975, pp. 9-10.

seems attached to a slab of petrified material of some sort. With these monuments, the memorial function is identified with the fossiliferous, as if petrification were somehow more related to memory than to forgetfulness. These fossil memorial trees remind me of the large concrete tree stump in Brancusi's Park at Tirgu-Jiu.

Sculpture is an art of the tomb. To understand this, it is only necessary to believe what is obvious, that life is temporary and that death is permanent. Sculpture, as a sign for the petrified body, represents life by means of the appearance of death: the inevitable calcification of once flexible joints, *rigor mortis*, and the skeleton. By mimicking the stiff appearance of death, sculpture gives to the subject model and the spectator alike some measure of the eternity that belongs properly only to death.

We all live out the myth of Pygmalion and Galatea in reverse. Recall Carl Andre's course of development of 20th century sculpture (from Form to Structure to Place) as the record of the body passing into death. Its sternest critics have dismissed Modernism as formalism and formalism implies a rigidity of social manner, a stiffening of the body. A corpse is called "a stiff". Modernist self-denotative sculpture represented its own death.

In a small square, near where the two main village streets intersect, is an over life-size statue of a soldier, a war memorial in the style of Sargeant Jagger.[133] It is isolated on a concrete island between opposing lanes of traffic, standing like the castaway from J.G. Ballard's story, *Concrete Island*,[134] but here the automobile traffic is slow and with some care, the monument can be approached. Intended as a cenotaph memorial to the local dead of the First World War, the sculpture represents a British soldier of the 1914-1918 period in full battledress, poised contraposto, his right hand

[133] Sargeant Jagger, *Modelling & Sculpture in the Making*, 1933.

[134] A story about a man marooned on a concrete traffic island. J.G. Ballard, *Concrete Island*, 1976.

grasping the stock of his Lee-Enfield rifle. The statue and the pedestal are both carved from a pale yellow limestone.[135] Marine fossils are exposed in section across the face of the pedestal and there is a bronze plaque fixed to its surface that reads:

IF YE BREAK FAITH
WITH US WHO DIE
WE SHALL NOT SLEEP
THOUGH POPPIES GROW
IN FLANDERS FIELD
(… And the unsleeping statue continues to speak to us …
I THINK — THEREFORE —
I AM TURNING INTO STONE
AND THOUGHT, LIKE A LIQUID
FLOWS THROUGH ME QUICKLY)

The sculpture reminds me of the short tragic life of the Vorticist sculptor Henri Gaudier-Brzeska, killed during the First World War at the age of 23. But the text reminds the Sculptor that she is both thirsty and hungry, that she needs to go to the washroom and that she needs to take a pill. We recognize the white plaster and black timber facade of a nearby building as that of a pub. Inside, on each side of an untidy bar are two snug brown rooms. The furniture is antique, the walls panelled in dark oak. An open fireplace gives off a warm autumnal glow. We order and are served a meatloaf pie, which we each wash down with a pint of lukewarm beer. The experience is like being inside a bronze sculpture by Henry Moore. Through a small panelled window, I can see outside to the statue of the soldier. There is a robust man with a large red moustache and a bulldog on a chain leaning at the

[135] Limestone is traditionally the stuff of funerary monuments. The word sarcophagus derives from the Greek term for "flesh-eating." It seems that the lime leaching out of the limestone box was capable of dissolving the enclosed body. Given enough time, sarcophagi could be reused.

bar talking to the bartender, who calls him "Major". They are trying to get the dog, a bulldog named "Winston", to drink beer. The "Major" starts to tell war stories.

"I pinched from the enemy a Mauser rifle. Its heavy unwieldy shape swamped me with an image of brutality ... I broke the butt off and with my knife I carved in it a design, through which I tried to express a gentler order of feeling which I preferred. But I will emphasize that My Design got its effect (just as the gun had) FROM A VERY SIMPLE COMPOSITION OF LINES AND PLANES."[136]

Sergeant Henri Gaudier was killed at one o'clock in the afternoon of June 5, 1915, while leading an attack on the "labyrinth" at Neuville St. Vaase. He had only recently written to Ezra Pound that he had been neglecting his reading and that an empty head was an inviting place for a bullet.

Compare two of Gaudier's portrait heads. *Portrait of* (Horace) *Brodzky*, 1913, is clumsy, as if the clay had been carved rather than modelled. The bronze integument itself is thick and the sculpture is much heavier, much more of a monolith, than necessary. I once had the occasion to lift this sculpture during an exhibition installation and was surprised by its unreasonable weight. *Hieratic Head of Ezra Pound*, 1914, was not modelled, but instead was carved directly in a large block of white marble, the features stylized into crystalline facets. Yet the geometry is blunted like forms in soft clay and the symmetry lacks too deadening an exactness.[137]

[136] "Vortex Gaudier-Brzeska from the trenches", *Blast*, No. 2, 1915.

[137] Compare Gaudier ("Vortex Gaudier-Brzeska", *Blast*, No. 1, 1914) on Egyptian sculpture: "His Gods were self made, he built them in his image and RETAINED AS MUCH OF THE SPHERE AS COULD ROUND THE SHARPNESS OF THE PARALLELOGRAM," and Joseph Beuys on *7000 Oaks*, "... we found basalt columns which are part crystalline, that is to say,

Gaudier was a primitivist as well as a futurist, and revealed in *"Vortex Gaudier-Brzeska"* an encyclopedic knowledge of the pre-classical carving tradition. But he echoed Baudelaire's dismissal of sculpture as "Carib"[138] art, concluding that the expressive range of primitive art was too narrow, capable of expressing only serene joy or exaggerated sorrow, and proposed instead the continuation of the sculptural traditions of "barbaric" sculptors,[139] by which he meant the small, portable sculpture of nomadic cultures. Unlike his contemporary, the Futurist Umberto Boccioni, who believed him self to be a truly modern primitive, untainted by archaisms, Gaudier insisted that he was continuing the sculptural traditions of the *Volkswanderung.*[140]

He carved the ivory handle of a toothbrush and was happily surprised when it was mistaken for the product of a genuine "barbarian". As a modernist animalier, Gaudier haunted the London Zoo. He drew and sculpted animals, deer, monkeys, fish, gorillas, and birds. Unlike Boccioni, whose modern works were ironically cast in traditional bronze, Gaudier carved brass directly, attempting to achieve the modern without compromising his commitment to carving. His vision of the modern artist was of an urban nomad, restlessly "expressing abstract thoughts of conscious superiority".[141] During his last year in London, he carved small

they have sharp corners, but at the same time tend toward amorphousness" (Stüttgen, *Beschreibung eines Kuntstwerkes*, Düsseldorf, 1982).

[138] Hal Foster, "The Un/making of Sculpture", *Richard Serra Sculpture 1985-1998*, 1999, p. 20.

[139] "(That) this sculpture has no relation to the classic Greek, but that it is continuing the tradition of the barbaric people of the earth I hope to have made clear", Gaudier. Ezra Pound, *Gaudier-Brzeska, A Memoir*, 1916.

[140] Wyndham Lewis lamented from the 1920s that Gaudier-Brzeska had been, "essentially a man of tradition" and "not starkly 20th century enough. W.K. Rose, *The Letters of Wyndham Lewis,* 1963.

[141] Henri Gaudier-Brzeska, "Vortex Gaudier-Brzeska", *Blast*, No. 1, 1914 p.158.

pocket sculptures directly in brass: *Toy, Ornament and Charm*. He also made weapons, carving a series of brass knuckle-dusters as gifts for friends.[142]

> "And we the moderns ... through the incessant struggle in the complex city have likewise to spend much energy ... we have crystallized the sphere into the cube, we have made a combination of all possible shaped masses-concentrating them to express our abstract thoughts of conscious superiority.
> Will and Consciousness are our VORTEX"[143]

With the outbreak of World War I in 1914, Gaudier left London for France. He wrote to Ezra Pound of "leading Rosalie to the dance." "Rosalie" was his 20-inch bayonet, so-called because, "we draw it red from fat Saxon bellies".[144] He also carried a nine-and-a-half-pound Lebel rifle, "La Belle" to the troops. The Lebel was the first modern rifle, chambered for small-bore

[142] The knuckle-duster is a vestigial form of *Gadlings*, the offensive spikes on the knuckle-plate over the finger joints of a medieval armored gauntlet. See Charles Boutell, *Arms and Armour in Antiquity and the Middle-Ages*, 1874. In America they are known as "brass knuckles". Ezra Pound, *Gaudier-Brzeska: A Memoir*, 1916. See also the Futurist sculpture by Giacomo Balla, *Lines of Force of Boccioni's Fist II*, 1915, Hirschorn Museum, Washington.

Some artists can seem irrationally hoplophobic, but there is a faint history of their weapons. Michelangelo's sword is in the Vatican. Gauguin hunted with a Winchester rifle and Alberto Giacometti routinely carried an *Apache* pistol on his nocturnal wanderings. (This from a personal conversation in 1974 with his friend, Marthe De Sadeleer. The *Apache* pistol is a criminal weapon named after Parisian street gangs, who in turn borrowed their name from the southwest North American tribe. It combines a small caliber revolver, folding knife and knuckleduster in one weapon.)

[143] Henri Gaudier-Brzeska, "Vortex Gaudier-Brzeska," *Blast*, No. 1, 1914.

[144] Ezra Pound, *Gaudier-Brzeska*. 1916. The German soldiers referred to the French bayonet as the "knitting needle".

87

smokeless powder ammunition, but by 1914 it was already a relic, clumsy and slow to reload.

"We have the finest futurist music Marinetti can dream of, big guns, small guns, bombs ... with a great difference between the German and the French ... the different bits of whistling from the shells, their explosion, the echo in the woods of rifle fire, some short, discrete, others long, rolling ..."[145]

In his letters Gaudier described the violence of combat as "the greatest fun ... of all my life" ... but mourned the loss of his carving knife: "[I] lost my knife while falling down to avoid bullets from a stupid German sentry, whom I subsequently shot dead, but the stupid ass had no knife on him to replace mine, and the bad humour will last another week until I receive a new one."[146] Gaudier-Brzeska's last sculpture was a maternity figure, carved from the walnut buttstock of a captured German Mauser rifle.[147]

Peter Paul Mauser's last design was for a firearm constructed without pins or screws, allowing it to be disassembled and reassembled without the aid of tools, like a three-dimensional Chinese puzzle. Testing it at his outdoor firing range, he caught a chill and died, one year earlier than Gaudier, just prior to the outbreak of the First World War. Peter Mauser had grown up in the shadow of the Black Forest in the Swabian village of Oberndorf, where he spent his entire life. He lived there within a former Augustinian cloister, a part of his production facilities.

[145] Ezra Pound, *Gaudier-Brzeska, A Memoir*, p. 50.

[146] Pound, *Gaudier-Brzeska*, p. 50.

[147] While in Polynesia, Paul Gauguin hunted feral pigs with his Winchester rifle. Thor Heyerdhal located it during his *Fatu-Hiva* years. When a French colonial bureaucrat attempted to confiscate it, Heyerdhal removed and kept the walnut butt stock, covered with Gauguin's carvings. Thor Heyerdahl, *Fatu-Hiva*, 1974, pp. 168-169.

His rifle, the famous Mauser 98 (finalized as a practical design in 1898) was milled from a single block of forged steel, rather than being constructed from any number of stamped, cast or scintered steel parts, as in more recent firearm production. It was essentially a carving in steel.[148] A genuine cult of the Mauser existed in Germany and has since developed in North America, a legacy of the postwar conversions of innumerable "war trophies" into American sporting rifles. The accurate and powerful bolt-action Mauser has become a totem of the political right as a representation of mythical white male virtues such as precision, reliability and accuracy, that is, rightness. The intellectual right believes, with Ezra Pound, that, "our community is no longer divided into 'boheme' and 'bourgeois' ... we have men who invent and create, whether it be a discovery of unknown rivers, a solution of engineering, a composition in form, or what you will. These men stand on one side, and the amorphous and petrified and the copying stand on the other."[149]

During WWII, the greatly outnumbered German army adopted the Sturmgewehr (assault rifle), abandoning the careful hand-fitting of carved steel parts in favour of a production method based on the relatively unskilled use of the sheet steel punch press. Soviet designer Mikhail Kalashnikov based his rifle on the German design; the Automatic Kalashnikov, or AK-47 (finalized as a design in 1947). Gaudier-Brzeska's Lebel rifle was a perfectly finished mechanism, with each part fitted by hand, but the design was an inefficient one. The Mauser relied more upon its design than on the strength of its steel or the quality of fitting and the Kalashnikov dispensed with all handwork and relied completely on its design. It can be manufactured in the simplest of production facilities and still function reliably with generous tolerances

[148] The contemporary firearms community is not unaware of its modernist aesthetics; a writer for one firearms journal coined the neologism "Brancusoid" to describe the ovoidal detailing on certain shotguns.

[149] Ezra Pound, *Gaudier-Brzeska, A Memoir*, 1916, p. 98.

between the relatively crude parts of the mechanism; the Mauser less so, and Gaudier's Lebel rifle not at all.

In June 1915 Gaudier led a charge into the masterpiece of German engineering known as the "labyrinth", a complicated maze of trenches and galleries, dug into the earth and strengthened with brick and concrete, south of Neuville St. Vaase. I imagine that Gaudier spun like a top when he was shot, then staggered off into one last dance with "Rosalie" and "La Belle" as the "finest futurist music" played. I doubt he knew that he was dead until the advancing soldiers passed right through him.

Henry Moore returned to England invalided from this same war. He had been gassed, later served as a bayonet instructor, but was otherwise physically unharmed. He began his postwar career as a sculptor under the influence of early modernist carvers such as Gaudier-Brzeska, adopting their primitivist ethic of truth to material and the carving technique of *taille directe*. He had the same prerequisite interest in and artifactual understanding of primitive art; an understanding that, according to Moore, "(had) come entirely from continual visits to the British Museum".[150] During the 1920s Moore adopted a style somewhat after the manner of the Alsatian Surrealist Hans (Jean) Arp,[151] a synthesis of the forms of worn stones with those of the human figure. During the years of the Second World War, 1939-45, he temporarily abandoned carving and sculpture, and worked instead on a series of drawings of coal miners (Moore was the son of a Yorkshire miner) and the inhabitants of underground air-raid shelters. This theme of enclosure dominates all his later work. After 1945, Moore abandoned *taille directe* in favour of bronze casting, that most indirect of methods, involving as it does the use of positive and negative moulds, wax and plaster casts, and the services of numerous assistants and technicians.

[150] Henry Moore, *Henry Moore on Sculpture*, 1967, p. 59.

[151] "In one aspect or another, my sculptures are always torsos." Hans Arp in H.H. Arnason, *History of Modern Art*, p. 301.

These post-1945 bronzes represent enclosure as an image rather than a fact. Consider that bronze is normally cast hollow, a fact that the casual spectator of sculpture can easily fail to appreciate. There is a difference between the apparent thickness of the forms of the image and those of the integument, the actual thickness of the metal. In Moore's work, what is apparently enclosed is not what is in fact enclosed. Several sculpture traditions consider this to be a significant distinction: The Hindu *Silpa-Sastras* (architectural canons) list the dire consequences that will result from the casting of anything but a solid statue.[152] But in Europe, bronze sculpture developed as an art of integuments and facades, a surficial representation of a monolithic form. In an actual monolith (recall the chalk cliff face at Dover, exposing the underlying geology), the surface is always revelatory of the core. In Moore's post-1945 sculpture, the surface does not reveal a core; instead the surface is a representation.

Skeumorphic or representational architecture is completed by means of an intermediary representation, usually a drawing.[153] An example of a skeumorph in architecture is the marble Doric temple such as the Parthenon with its prototypical form found in the timber structures of Classical Greek domestic architecture. The skeumorphic is a condition of an applied skin. In the relationship between facade and supporting volume, the volumetric becomes two-dimensional through a process of imitation. This process is most often initiated by a change in economic circumstance in concert with the development of the science of materials. For example, the development of electroplating technology, the limited supply of a valuable resource (silver) and the rise of a large middle class created the silver plate tea services of Victorian England. Similarly, in the 20th century, the development of a plastics

[152] Nirmal Kumar Bose, *Canons of Orissan Architecture*, 1932.

[153] Broadbent, "Deep Structures of Architecture", *Signs, Symbols and Architecture*, 1980, pp. 139-143.

technology, the vanishing supply of increasingly valuable hardwoods, and the economic rise of a large middle class all contributed to establish the production of veneer sheathing materials used in the production of furniture. The careful application of these thin sheets of false materials connotes youth and newness in contrast to a past represented sculpturally by carved wood. Yet it is this ideal of solidity and security embodied in the monolithic block of solid wood that is imitated in the skeumorphic veneer. Built middle class environments mimic the solidity of the materials and by association, the solidity of the values of upper economic classes.

Moore increased the scale of his production and changed his medium from stone to bronze at precisely the same time as his greatest financial and critical success. He had a retrospective at the Museum of Modern Art in 1946 and won the sculpture prize at the first postwar Venice Biennale. Moore's success corresponds historically to the postwar reconstruction of European industry (his large scale bronzes were cast in Germany) and the release on the market of the tremendous amounts of tin and copper (bronze) previously required for the manufacture of brass ammunition cases during wartime.

Moore's post-war bronze sculpture represents earlier work (the period of direct stone carving) via the transitional period of wartime drawing (1939-45). These drawings were overworked, scratched and abraded, just like the textured surface of Moore's bronze sculpture. The cast metal surface of the bronze has the appearance of carved stone: the marks of the rasp in the preliminary plaster (reproduced exactly in the final bronze) recall the parallel engraved lines left in stone by a point or a claw chisel. In other pieces, rows of plastered string outline form just like the crosshatching in the drawings … as they recall the briefly glimpsed lingerie bindings of *les filles plâtre de Paris*.

The surfaces of his drawings and the similarly detailed texture of the cast metal surface allow us to understand Moore's sculpture as the product of an enclosing mould. There is one particularly

English enclosure, a place remarkable for forms and texture coincident with those of Moore. This is the pub, the English home in its manifestation as a public house.

From the "ruddy radiance ... and extraordinary comfort"[154] of Sir Arthur Conan Doyle's London, to Tom Brown's "uncommonly comfortable"[155] study at Rugby, it is the place, as described in Victorian literary fiction, that established the paradigmatic interior of the English place. Here we find a special place characterized by a "solid brownness that was most secure".[156]

The English pub is a Victorian recollection of an Elizabethan public cottage, an assemblage of pre-industrial qualities. The typical pub, concealed behind a reproduction daub-and-wattle facade, is a dimly lit maze of cosy rooms. Rustic timbers support creaking white ceiling planks. The furniture is worn and antique. Walls are either panelled in dark antique oak or painted but with unplastered stonework (revealing also the relativity of the truth to materials aesthetic). The pub is a "British museum" (recalling the source of Moore's primitivism), a place of recollection and display, the walls covered with hunting prints and shelves glowing with the trophies of remembered sport and forgotten military campaigns. Over the bar hangs a collection of old pewter tankards, and behind is the glowing collection of beers and liquors. An open fireplace gives a warm autumnal glow to each snug room. A "simple but wholesome" meal is served, washed down with an unchilled glass of real ale that has an olde English brand-name like *Ringwood Old Thumper* or *Merrie Monk*. Here, cynical individualism is extinguished in the warmth of a common fantasy. The sculpture of Henry Moore collaborates in this secure brownness that recalls both the numinous and the ordinary. This is the colour of cooked meat, wood and earth, petrified bone, beer and bronze.

[154] Sir Arthur Conan Doyle, *The Lost World*, p. 46.

[155] Thomas Hughes, *Tom Brown's School Days*, p. 91.

[156] T.H. White, *The Once and Future King*, p. 28.

"It was a hobbit-hole and that means comfort."[157]

Contrast the Flemish domestic interior, characterized by signs of care, with an English interior, characterized by signs of wear: "[The pub is] more homey than any home can sensibly be ... pub comes from public ... a special sound signifying cosiness and contentment ... [The English] have made themselves comfortable by preferring a muddle or a jumble to any sort of effect. Pubs are eminently Victorian ... they deliberately give body to a dream of the past ... Elsewhere they have become gleaming cafés, while in England they are more villagey than ever, more like burrows ... [In] Holland and Belgium ... the houses ... can he seen right through ... a tinted-glass window in front matching one in back ... The English home is separate from the world by being closed in, the Flemish by being cleared out. The English rejoices in signs of use, the Flemish in signs of care, of work."[158]

Moore's bronzes are textured, abraded significantly like pre-distressed furniture.[159] They invite one to touch, not in the way that the extreme polished surface of a Brancusi or the painted surface of a Donald Judd sculpture dare one to touch them, but in the way of a long familiar furniture surface. Moore's reclining figures recall furniture as much as figure; they have the stuffy, enclosing forms of a chesterfield and the attendant signification of bodily comfort and domestic security. I recall English sculptor William Tucker's 1984 exhibition at the David McKee Gallery in New York: his Henry Moore-like bronzes looked especially like upended couches.[160]

[157] J.R.R. Tolkien, *The Hobbit*, p. 3..

[158] Robert Harbison, *Eccentric Spaces*, 1977, pp. 27-28.

[159] New furniture that has been stained and beaten, creating the signs of wear necessary to the effect of the antique.

[160] Although, "small enough to hug", according to Tucker in personal conversation with me in 1985.

First Adrian Stokes, and later Herbert Read, popularized the sculpture of Moore, explaining it in relationship to the notion of wear as a sculptural experience. Stokes's *The Stones of Rimini*, though ostensibly a study of the Neo-Platonic sculptor Duccio, was actually a modernist apology. Stokes rejected the conventional allegorical interpretations of Duccio, and appreciated him eccentrically. He related Duccio's limestone relief carvings to the geological process of weathering and deposition. Read extended Stokes's critique by means of a contrast between organic Neo-Vitalism (by which he meant Henry Moore and Surrealist sculptors like Hans Arp) and Constructivism (by which he meant the international work of the ex-patriot Russian brothers Naum Gabo and Antoin Pevsner, and the art of the De Stiji group).

Read's categories can be displaced by Robert Harbison's categories of use and care. Understand Neo-Vitalism as an equivalent to Harbison's conception of "signs of use". Then understand Read's Constructivists, particularly the De Stijl group, to have developed within a built environment characterized by "signs of care". This equation displaces Henry Moore from his awkward position within the Modernist canon and relocates him within the paradigmatic English place: Henry Moore in the pub.

Barbara Hepworth seems to have left the pub before closing time: her work lacks the drunken list and leer of sculptures by Moore. It is more clear-headed, and more soberly rejoiceful of labour. Unlike Moore, Hepworth prepared few drawings as a preliminary to her production of sculpture. She worked more after the manner of Brancusi, developing each sculptural conception fully in her mind before carrying out the work in a relatively straightforward manner.

Hepworth's sculpture developed through three stages. The first was a Neo-Vitalist phase informed by French Surrealism, done in close association with Henry Moore. After 1935 she produced a series of crystal like carvings under the influence of the Naum Gabo and Piet Mondrian, both of whom she knew as exiles in England. Her final monumental style combined Constructivism

and Surrealism, a rare conflation of the domestic securities of England and Flanders.

Henry Moore's paradigmatic sculptural form was the worn stone or fossilized bone (mineralized or natural brownness) in its social incarnation, a cooked steak bone (cooked or cultural brownness).[163] For Hepworth, the sculptural paradigm was the tide-tumbled seashell (in its domestic incarnation, ceramic dishware). Within the English domestic interior, Henry carved the beef and Barbara did the dishes.

Socialize the entire British sculpture enterprise since 1945 by placing it in the pub. Consider all the "new" generations of British sculpture: the 1950s "Geometry of Fear" group,[162] the 1960s "New Generation",[163] the peripatetic post-studio "New Art" of the 1970s,[164] and the "New Art" sculpture of the 1980s.[165] Each of these "new" generations was created through the prescriptive curatorship of large decadal theme exhibitions. The emphasis of each exhibition was always on the "new" but the sculpture always

[161] Recalling Brancusi's dismissal of the sculpture of Michelangelo as *biftek*, and a consideration of that of Moore as *biftek cuit*.

[162] The post-war pub as a ruin; the expressionism of Lynn Chadwick, Kenneth Armitage, Reg Butler and his well-known submission to the CIA-sponsored cold-war competition for a "Monument to the Unknown Political Prisoner".

Robert Burstow, "Butler's Competition Project for a Monument to 'The Unknown Political Prisoner': Abstraction and Cold War Politics",*Art History*, (Vol. 12) No. 4, December 1989.

[163] The high modernism of Anthony Caro and his followers, the quasi-minimalism of William Tucker and William Turnbull, the pop-sculpture of Eduardo Paolozzi.

[164] The "walked" sculptures of Richard Long and Hamish Fulton, the early process art of Barry Flanagan, the performance art of Gilbert and George, who have exhibited photographs of their drinking bouts in pubs.

[165] Tony Cragg, David Nash, Anish Kapoor and Rachel Whitread … who has taken positive plaster casts of entire building interiors.

seemed old and British sculpture always remained firmly seated in the pub.

There are many stories of nomads being afraid to sleep inside a house for fear the roof will collapse on them. They had become so conditioned to flexible fabric overhead that a solid roof constituted a threat. But the nomad lives not so much in a tent as in a landscape being traversed. As the English find psychological security in a "muddle or a jumble" (Harbison), the nomad finds protection by means of alertness within an open landscape. Nomadic clothing is nomadic architecture and nomadic architecture is clothing. The reclothing or re-erection of the architectural fabric in different locations is expressive of transience. As the psychological security dependent on signs of care in Flemish domestic architecture is the maintenance of an existence in a perpetual present time, and the security related to the signs of wear in the English pub is an existence in a perpetual past time, so nomadism is a never completely realized future time.

Contemporary peripatetic post-studio art is an aspect of this unsettledness. A sense of place has developed in which psychological security is found signs of transience rather than in signs of wear or care. But as signs of transience have been socialized as signs of wear (… the muddy footpaths of Richard Long in the 1970s, the neo-detritus of Tony Cragg in the 1980s … and on and on until today …) contemporary nomadism in British art is somewhat disappointingly revealed as a romance, a story drunkenly recounted in a pub.

As a child, the Sculptor made several trips to Toronto, Canada, and she remembers her father being particularly fond of the Henry Moore Collection at the Art Gallery of Ontario. She tells me that she spent what seemed to a child like a great deal of time canvassing every inch of that room. She even gave a little impromptu dance performance, while an art student sketched her. She doesn't remember the dance, but she still has the drawing. This was her introduction to the art world, or more specifically, the

world of modern sculpture. Recall Henry Moore's visits to the influential British Museum.[166]

The Sculptor once made lightweight Styrofoam carvings, modelled over with a thin coat of plaster, textured in imitation of driftwood, and then painted in imitation of wood. They resembled nothing so much as patinated bronze, a *faux* surface for a photo opportunity. As a synthesis of neo-vitalism with pop culture interior decoration, the sculpture functioned as a model of the development of English sculpture since Henry Moore; the "signs of use" (wear) appropriated by signs of transience. Resistant to naïve readings of the natural,[167] its nature was cultural and its culture was grounded in a nature again culturalised. As the work pretended to be sculpture about sculpture, it pretended no less to be sculpture about driftwood and driftwood about sculpture. Ideationally sensuous and critically anxious, doubtful of place yet undoubtedly sculpture; it undoubtedly expressed Gaudier's "abstract thoughts of conscious superiority."

The Sculptor grows bored with all the drunken war stories of Gaudier-Brzeska and Henry Moore, and she does not return from a trip to the washroom. I find her only later, passed out, dreaming on her bed. I throw a white bedsheet over her torso and pills scatter over the floor. I get down on my knees to pick them up.

They are antidepressants with soothing, wellness-designed names: Paxil and Prozac, Xanax and Zoloft, names like strange

[166] Sculpture in Canada is still "written" in English. Consider Anthony Caro's *Prairie*, 1967, a yellow horizontal construction of steel, long considered a seminal work of late modernism, within the context of provincial (representational) modernism. An entire school of Modernist welded steel sculpture survives as an anachronism in cities scattered across the Canadian prairies. I once met one of these provincial sculptors in New York, just after he had met with Clement Greenberg for the first time. He was ecstatic. "Clem", as he called him, had told him that he was "on his way". Other work exists in deliberate contrast to this sculpture.

[167] Such as those revealed in the over sweet lyrical photo-sculpture of English artist Andy Goldsworthy.

planets, other and utopian worlds. Viewed up close on the floor they become sculpture, large nude plaster replicas of themselves, sculpture that is by turns satirical and melancholic, comically utopian and hopelessly pessimistic. If this drug spill is sculpture, the Sculptor is a troubled teen in an overfull adult medicine cabinet, the cornucopian parking lot of a fleet from planet Xanax.[168]

This sculpture looks good, for the same reason that much of British sculptor Rachel Whiteread's sculpture looks good, because the particular *objet trouve*, when enlarged (or topologically inverted, in Whiteread's case) mimics the secure formal conventions of Modernist industrial design.[169]

The sculptures have the approximate size and form of ceramic pottery but are solid, recalling Brancusi's *Cup*. On this scale the pills are busts, Brancusian eggheads.[170] As sculptures of antidepressant pills, they become mythic vessels of inexhaustible plenty, cornucopia capable of marvellous rejuvenative powers.

When pills are the size of the human body, they become torsos, statuary distressed or historicized.[171] As a representation of the fecund female body, swollen belly or breast, fetishised as a phallus or a rigid corpse, they are made deathly hard. Memorials to the erasure of productive anxiety, models for monuments to the victims of the treatment of depression, they represent the post-Prozac nude, a truncated torso without head or limbs, without mind or mobility. They are gendered by their smooth white surfaces, their immobility (recall Giacometti's frozen prostitutes)

[168] "I live on Xanax," a tranquil fine arts professor at the Nova Scotia College of Art and Design once bragged to me.

[169] Tom Lubbock, "The Shape of Things Gone", *Modern Painters*, Autumn 1997.

[170] As Brancusi claimed the human head as "an egg where little cubes seethe," so here the human head is a cube full of eggs (pills).

[172] Again, "... the classical torso that we really love", Oswald Spengler, *The Decline of the West*. 1918.

and the impressed ownership mark of the corporation (the glyphic trademark logo). These are the bodies of women dismembered, immobilized by Giacometti's gaze.

Pills are like seeds that sprout to enclose the self within their architecture. Consider them as utopian architectural models, representations of a place where one is whole and happy, a childhood remembered or a death imagined, yet paranoiac. They are models of the Pantheon at Rome, the Newton Cenotaph of Etienne Louis Boullee and the Guggenheim Museum, Brancusi's *Temple of Redemption* for Indore and the stadiums of Albert Speer. All are now *sans oculi*. That all-seeing eye in the sky is supplanted by or revealed as the corporate trademark.

Historically sculpture can be divided into that which was made for a group of worshippers, and that which was made for the individual collector. In the former, the material is concealed by colouring or gilding, to make the sculpture seem more lifelike or more precious. Consider the monumental chryselephantine pagan statues of Ancient Greece or the gigantic Buddhas of Gandhara (attacked by successive waves of invaders but finally destroyed only recently by the Taliban). On the other hand, subtle types of rarity on a smaller scale attracted individual connoisseurs to curious patinas in metal or natural colours in wood, and by bare clay with traces of the artist's hand.

As religious institutions were once the sole inheritors of the supranational scale, so now the similarly omnipotent authority of contemporary corporations own the gigantic scale that surrounds one as the "gilded" illusionary surface of the built media environment. The electronic media is the contemporary equivalent to the sculpture that was once made for a group of worshippers.

The Sculptor drives the truck off the highway and onto a small road that circles to the left, her body swaying toward me, to the right. Her bright red lipstick and dark sunglasses flash complementarily against green hills that here and there reveal white patches of gypsum. She can smell the quarry, but she cannot yet see it. A few kilometres more, then suddenly, and it seems

about halfway around this bank of hills, is the entrance. She turns quick, sharp left, through an open gate in a steel fence, accelerating past the "No trespassing" signs. It is Sunday. No one is working and there are no guards. Fast on gravel and then down an inclined ramp, cutting though the overburden of gray shale and red sandstone. We stop in the centre of an immense pit. It is a plaster moon crater, a gigantic coliseum of eroded, pale flesh-pink gypsum. There are five small, white, nearly triangular clouds in the blue sky above the elliptical rim of the bowl.[172] She backs the truck up to a pyramid of stone. Obeying her instructions, I begin to select the most alabaster-like of the loose boulders, struggling to heave them into the back. They are large and heavy. Some are the size of human torsos. Others are more like heads.[173] She is in a hurry and imagines the gaze of an audience from the stratified tiers of pink stone piled up around us. Soon we are back in the truck, spraying gypsum gravel as we climb out of the pink hole, back past the quarry office and the warning signs, winding back out, now turning clockwise, now always to the right.

[172] Constantin Brancusi, *Birds in the Sky*, watercolor and gouache on paper, 1930-36

[173] According to L. Heber Cole's *The Gypsum Industry*, 1930, in this quarry " the rock is broken to man size" while in another nearby quarry the rock is " broken to hand sizes"

Chapter VI
A Journey to the Circumference of the Earth

"I had not yet looked down into the bottomless pit into which I was about to plunge, but now the time had come. I was ashamed to draw back in the presence of the guide … I leaned over a projecting rock and looked down. My hair stood on end. The fascination of the void took hold of me. I felt my center of gravity moving, and vertigo rising to my head like an intoxication."
— Jules Verne, *Journey to the Center of the Earth*

Pyramidologist Adam Rutherford's book *Iceland's Great Inheritance* contains a map, one that shows supposed alignments between the Great Pyramid and Reykjavik, the capital of Iceland. We take the night flight north.

Free champagne is served at the opening of a group exhibition of the Association of Reykjavik Sculptors. There is large wood carving of a bird perched on a vertical log pedestal that is also a champagne bottle rack. People are drinking, and I notice, after a time, that the sculpture rack is empty. Only later do I see a photograph of the Sculptor performing with the sculpture, wearing an iron vest with bird profiles cut from it, pouring champagne for his guests.

The names of the artists in the exhibition blur together. Icelandic names are difficult for me to pronounce. Many have nicknames. Björk Gudmundsdottir, whom I meet at the opening, is the singer Björk.[174] Ruri exhibits a blue Icelandic basalt cube titled *Cubic Metre*, in which she has inlaid a ruler adjusted to show a measurement of 21.5 cm.

Around the block from the Sculptor's Association, the Sculptor and I are mixing concrete on the floor of Gallery 20 M^2. The floor has been transformed into a libation table, mounds of cement and gravel aggregate, ponds of water. We mix sand and gravel in proportion with cement to make the concrete. Purchased in sealed commercial sacks, this aggregate is unique to Iceland, porous (but very hard) black basalt beach pebbles mixed with fragments of white seashells. We pour the concrete into plywood moulds and cast two one-meter square scale representations of a small crystal of calcium carbonate. One is placed at the centre of the gallery. Its double is placed outside in the rain.

The installation is a model for the permanent relocation of one sculpture to the geographic center of Iceland, the other to a position on the circumferential ring road around the island. According to our calculations (drawing from corner to corner of a six-by-nine-feet square geology map), the center of the country is just north of the ice cap of Hofsjökull. The Sculptor wants to recruit the Icelander Magnus Ver Magnusson, once the world's strongest man, to carry the block to the centre. She slides one end of the block across the slippery concrete floor and tells me that Icelandic women are taught by their mothers to be strong.

There is opposition to the placement of the work from a group of local artists. They venerate the center of Iceland as an unpolluted and virginal place. They use the word "pure" and understand the concrete crystal sculpture as a foreign seed. A newspaper article is written against the work. But by the time the Sculptor is called

[174] "Berk", English "birch".

upon to defend the placement of the sculpture (during an interview on Icelandic public radio) the difficult task of installation has already been accomplished. The Sculptor intends to produce a postcard of the work, giving the precise geographic coordinates of its location.

In Reykjavik, I see an exhibition of works by a New York-based Icelandic artist who builds Sol Lewitt-like steel-box grids, then blows them apart with semi-controlled explosions. In his colourful exhibition catalogue is a photograph of a sculpture made from spent shotgun shells. Downtown, at the end of the main shopping street, near the parked whaling boats, we stop in at the shop of a master gunsmith. He shows us a photographic portfolio of his work and a custom Husqvarna Mauser Model 98 sporting rifle. The metalwork is fine, the woodwork only slightly less so. He also makes knives with reindeer antler handles but admits that the blades are imported, that he is no Volundur. The Sculptor tells me that Volundur was a mythic metalsmith, imprisoned by a Nordic king to labour on a remote island of fire and ice. After raping the king's visiting daughter and killing the king's son (and turning his skull into a cup) he escaped on wings that he had made. Volundur left behind a fabulous maze, still partially visible, known in Iceland as Volundur's House.[175]

In Reykjavik an empty café that serves only alcohol[176] quickly fills with people at 11 PM; packs so tight that no one can move to the dance music. Our table fills with strangers. A beautiful pale woman with white-blonde hair moves to sit next to me with her back to the wall. She never moves. Her friends come to her to say hello. Popular because of our coincidental proximity to her, she begins to introduce us to her friends. The alcohol is too expensive

[175] The Anglo-Saxons also knew this once very popular legend, as the story of Weyland the Smith. It is apparently derived from the myth of Daedalus.

[176] Across the table, and the ubiquitous and illegal amphetamines under the table.

to share but she provides the Sculptor with free cigarettes. Over the din they signal with smoking gestures, hand to mouth, as if blowing kisses. These are the only motions of the frozen beauty. At a nearby table, with his back also to the wall, is a great lump of a man. I can hear his wheezing breath through the rare holes in the sound of the music, clinking glasses and loud conversation. He is fat, a rarity in Iceland. His thick eyeglasses, his long tangled hair and beard conceals his swollen red face. He is quickly chainsmoking, but drinks slowly. Like the beautiful woman, he rarely moves, and then only very slowly. He is overdressed in black and blue wool, as if always cold, a frost giant. The Sculptor jokes about the way artists seem always to wear black, as if they are attending a funeral. Sculptors themselves seem to prefer black and blue (collars and jeans), the colour of bruised flesh.

As the stasis of the woman at the table is a consequence of her beauty, the fat man's immobility is the mark of the beast. I am told that he was once a respected and slim young poet. On his first visit away from Iceland, to New York City, he drank too much and walked down the wrong street. I know that street, once lived around the corner. The Hell's Angels clubhouse is on that street. For some reason (or perhaps for no reason) the Angels beat him; they beat him so severely that he remained forever partially paralysed. He returned to Iceland and became sedentary. He no longer writes.

Back in my room, I open the windows (I like the way that Reykjavik smells of fish) and lay down on my bed. It is 3:30 AM. My cheap IKEA bed is suddenly rocking, threatening to collapse. It is a minor earthquake, but I am too tired to care. It rocks me back to sleep. I dream of an exhibition that I saw earlier in the day at Nordic House Gallery ... unassembled IKEA furniture laid out on IKEA carpets in imitation of the Suprematist paintings of Kasimir Malevich.

We circle the Hekla Volcano over three days, travelling in an eight-wheeled Mercedes 4x4 *Sleipnir*. (Icelandair played the movie *Volcano* on the flight to Reykjavik.) Stone cairns mark the

gravel roads, each pile just barely visible from another. We cross over flooded rivers (caused by what the Sculptor laconically refers to as "volcanic activity.") Hekla was one of the two medieval entrances to Hell[177] and was recast by Jules Verne as the mountain Snaefelljökull, the entrance to the center of the earth. In Norse mythology, Hel is the ruler of the underworld. Her face is beautiful, her body a corpse.

The landscape here is white volcanic gravel, overlain with black, so that the road cuts white through black. There are ellipses made by dirt bikes and 4x4 trucks, like those Michael Heizer made during the 1960s in the southwest deserts of the United States. Iceland is big sky country, Montana with an ocean. There are 70,000 horses in Iceland and innumerable sheep. It seems familiar. I spent my childhood near the farm of Stephan Stephansson, an Icelandic poet who immigrated to North America (d. 1927). I have been in his house and have looked through his books; Icelandic books that I cannot read. Everyone I meet in Iceland knows who he is. The Sculptor knows his middle name.

Icelandic landscape is barren, mostly lava and prismatic hexagonal pillars of basalt.[178] At the reconstructed medieval Norse farmstead of Stong, we walk around outside of the turf structure to examine the construction methods. There are two: the *strengur* method, using horizontal slabs, and the *klombruhnaus* method, where each alternating row of diagonal turf is set opposite to the next.

At Geysir the Sculptor and I wash our hands in a hot pool that smells of sulphur and stand side by side to watch the geyser Strokkur erupt. There is underground hot water everywhere in Iceland, always steam rising in the distance. In the hot springs at

[177] Mt. Etna was the other.

[178] Recent studies of the shifting magnetic poles suggest that the center of the earth may be composed of a single gigantic crystal of iron, a hexagonal prism aligned along the polar axis.

Landmannalaugar, the Sculptor tells me that she came here as a child but could not enter the water because the pools were full of "naked Germans", and her mother did not think it was appropriate. (Germans, the Sculptor tells me, have made a fetish of Iceland.) Iceland is a geological chimney sitting atop a branch of the mid-Atlantic continental rift that crosses diagonally from southwest to northeast, quite near our geographic centre of Hofsjökull. The *Althing*, the original Icelandic parliament, met on this geologic rift at Thingveller. Here we walk through the long narrow crevice of Almannagja, past a drowning pool for the execution of women (men were beheaded), beneath a waterfall, through a natural amphitheatre, where the Sculptor breaks into song, the words of which she knows I cannot understand, to the top of the cliffs. Large boulders balanced along the edge of the cliff, some propped one against the other, look like text, runes that I cannot read.

We walk over broken lava into the canyon of Eidgja, a 40-kilometre-long fissure running up to the southwest of the great Myrdalsjökull Glacier. There are lonely vertical stones here, statuary.[179] I know this is a narrow canyon, but all is mist. I can only see the back of the Sculptor's yellow raincoat as she scrambles over the lava. We are taking animal trails; cloven hoof prints show along the path. Our own footprints look more like ellipses, twisted off-centre with each stride. The path stops. A natural stone bridge once led across the Ofaerufoss waterfall, but it has recently collapsed. On the gravel plain below the waterfall, the Sculptor marks out a circle 42-feet in diameter. The walls of the canyon cannot be seen in the mist. She draws in an infinite space.

The diameter of the Sculptor's circle corresponds to the main ring under the big top of a travelling circus. (A performer standing on the back of a galloping horse as it moves along this path is able to perform because, as part of the dynamic equilibrium, the rider cannot fall. In a smaller circle, the rider falls outward. In a larger

[179] Locals claim them as dwarves that have been petrified by sunlight.

circle, the rider falls inward.) It is titled *Equestrian Monument*. I stand inside like a ringmaster and over the sound of the waterfall, read aloud from soaking wet paper sheets, the entire text of Baudrillard's *Radical Exoticism*. The mist begins to lift. The narrow canyon walls begin to appear, confining us as I read.

Before leaving, the Sculptor carefully erases with her foot all traces of the circle drawn in the gravel. We stumble back over the miles of lava. We step around a photographer who has tripped and fallen in our path. Baudrillard understands travel as bound up with photography, but I cannot walk on this broken terrain, with my torso twisting and turning, watching my feet, if I am also expected to take photographs. I recognize my own footprint, pointing toward me. Back at the hostel I play with two wild arctic fox pups, Geri and Freki, and close one eye as the Sculptor lectures me on Baudrillard. She thinks his text is like a waterfall, that his flowing narrative reveals his conceit, that his narrative is a one-way flood caused by egoistic "volcanic activity" under his glacial ice cap, and not circumambulatory at all.

"… the town (Reykjavik) itself might be in Canada and is quite commonplace, but all the houses are quite clean inside …"[180]

The architecture of Iceland recalls J.M. Gandy's *Architecture, Its Natural Model*, a watercolour in Sir John Soane's Museum in London. (The entire right side of the painting is devoted to prismatic basalt geologic formations.) Old Reykjavik was built in a shallow valley between two hills, each now crowned by a church. On the larger hill is the big Lutheran Cathedral, the Hallgrimskirkja, built in a style that the Sculptor describes as "Basaltic Gothic"; the repetitive cast concrete forms of the building derived from those of the basalt prism. The Sculptor says that it was an attempt by

[180] Gillian Naylor, Ed., *William Morris by himself, Design and Writings*, 1988.

"Iceland's Albert Speer" to produce a national style. Again she tells me that the Germans have made a fetish of Iceland. On a third hill we visit The Pearl, a building she describes as "the biggest, most expensive sculpture in Reykjavik". The Pearl looks like a huge silver UFO, a glass dome set atop huge cylindrical hot-water tanks. Inside are palm trees, a revolving restaurant and an artificial geyser. I remember the greenhouses growing bananas that I saw near the Hekla volcano.

In a glass case at the National Museum is a small bronze statue of Thor with his hammer Mjøllnir, also Viking weapons, swords, axes and spearheads. On the floor is a large recumbent stone carved in the form of a nude female torso. There is also the famous carved wooden doorway of Hylestad Church, on loan from Norway's Universitetets Oldsak-Samling. The carvings depict six scenes from the Volsunga Saga, not the scenes of Atli (Attila) and Gudrun, but instead the story of Sigurd the Dragon Slayer; the forging of his sword by Regin the smith from the fragments of Sigmund's sword Gram, and Sigurd's combat with the Örm Fafnir. I follow the sculptor as she steps through the carved portal.

The Sculptor wants to drive me across town to see an outdoor sculpture exhibition along the south shoreline of Reykjavik, out along the edge of the municipal airport runway. It is warm and sunny. I have street shoes, no hat and a thin jacket. It is cold and rain is falling by the time we arrive at the exhibition. No street runs parallel to the shoreline crescent. There is a footpath. The Sculptor has seen the work before and does not want to walk in the cold rain. We will meet at the highway, at the other end of the path. I reluctantly leave the warm car and with a map of the exhibition in hand, I begin my trudge along the footpath. There are many sculptors in Iceland, 24 of them in this exhibition. I walk slowly at first, leaving the path when necessary, wandering through rocks and weeds, carefully seeking out and inspecting the work. The map only gives a general indication of the location of each sculpture and I fail to find some of them. Ironically, some of the sculpture is intended to function as signage. As I grow colder I

increase my pace and give the later pieces only a passing glance. Most of this work I have seen before, not in Iceland, but somewhere. I slow to observe a large bird perched on a rock that is barely above the water, some distance out into the bay. The bird seems to be standing directly on the water. It is only when I approach closer and the bird does not move, that I realize it is a cast metal sculpture, *Geirfugl*, a representation of a large flightless bird, now extinct, once native to Iceland.

I walk quickly over the remaining route, several kilometres. I am looking forward to being warm, but when I arrive at the end of the cold crescent of the shoreline, there is no Sculptor waiting, only a busy highway and a concrete pedestrian overpass. For an hour I wait under the overpass in the rain. When she finally arrives, with a long confused explanation for her lateness, the Sculptor insists on walking back some distance with me in order that she can view some of the works. We find one of them, a forged iron grid framed by two tall pillars, painted white. It seems to be a gate. Through it we can see into a graveyard. But it is welded shut and does not open.

The Sculptor drives me around to some Reykjavik sculpture museums. She drives fast, and always with a large crumpled road map unfolded over her steering wheel, obscuring the windshield. She complains that Icelanders have too many accidents. She complains that they drive too fast and that they do not drive carefully enough. She runs the red lights and the stop signs. We visit three different sculpture museums, each the former studio-home of an Icelandic sculptor. It seems that a sculptor's home and a sculptor's studio and a sculpture museum are all very much the same place, that sculptors understand travel precisely because their art is sedentary.

One sculpture museum is a domed observatory-like building that is entered through huge Egyptiform pylons, all plastered white. Built in stages, during the mid to late 1940s, it houses work by Asmunðar Sveinsson (1893-1982). The Sigurjon Olafssons Museum is also white, but the Einar Jonsson Sculpture Museum

is grey concrete. It is the most prominent of the museums, located atop the central hill of Reykjavik, sharing the crown with the grey crystalline Hallgrimskirkja, its sculpture garden almost the churchyard. Jonsson's building is a moody romantic castle of a studio home. It recalls the other cast concrete castles, the castle in the Rockies made from embalming fluid jars, the Dia Castle on the Hudson, and the Romanian castle of Dracula.

A concrete wall completely surrounds the museum and the sculpture garden. The front entrance is no longer used and we walk around the circumference of the wall to the entrance at the rear. Here workers are noisily tearing down a portion of the wall that encloses the sculpture garden and I pocket a piece of it as a souvenir. It is the same strange dark Icelandic concrete, the aggregate of tide tumbled basalt pebbles mixed with seashells, as in the concrete sculpture of the calcite crystal at the center of Iceland.

In the sculpture garden are 26 bronzes. Inside are the original plasters for these and other larger works. The Sculptor directs me to both the exterior bronze and the interior original plaster relief that depicts *The Birth of Psyche*. Psyche is a nude torso at the center of the panel. She emerges from the attentions of the four elements, each of which approaches her on a broken axis. The figure of Earth is a sculptor, carving Psyche's back, bent over the chisel at a painful angle. The entire composition is in the form of a swastika. According to the Sculptor, this is the ancient Norse symbol of Thor and his lightning hammer Mjølnir as a gear in the industry of Volundur.[181] There is another relief that depicts a frost giant constructing Aasgard, the home of the Norse Aesir gods, from huge hexagonal pillars of basalt. Nearby is a very large plaster head titled *Hyild* (Rest), 1915-1935. Half of the face is visible, the rest covered with hexagonal prisms that follow the

[181] A blue swastika is still the corporate logo for Iceland's largest shipping company.

contour of the face beneath, an armour of crystalline scales, like the evolving creature in J.G. Ballard's novel, *The Crystal World*.

I hear the Sculptor calling to me from the head, but she is actually in the next room, pointing up at a gigantic plaster hand that holds a plaster crystal. It is titled *Demanturinn* (The Diamond), 1904-1905. It recalls "the Sign", the large quartz crystal ceremoniously unveiled in Germany at the Darmstadt Artists Colony in 1901 as an emblem of the new age. (The architect and designer Peter Behrens, once resident at the Darmstadt colony, based his famous 1908 hexagonal trademark for the German electrical firm of AEG on this sign.[182])

This giant paste diamond reminds me that plaster is itself a sign for the crystalline. In the production of plaster, raw gypsum is ground and heated to drive out crystallized water. When water is added to plaster, it recrystallises, "sets," and gives off heat as it reconverts to gypsum. I ask the museum guard, a large blonde woman wearing a pyramid pendant, if we may photograph the large sculpture in the upper gallery. She refuses, claiming that the flash from the camera will damage the plaster. When I suggest that we photograph them without the flash, she again refuses permission. She suggests that photography is a form of theft. I cannot help but agree. Later, without permission, I steal photographs of the smaller works on the unguarded floor below.

As the crystalline is historically a sign for clarity and illumination,[183] in Einar Jonsson's studio it is also a sign for the frozen body of the national state, a memorial to the stiff other of that corpse. (Jonsson was a theosophist and an ardent nationalist,

[182] Frederick Schwartz, "Commodity Signs: Peter Behrens, The AEG, and the Trademark," *Journal of Design History*, 1996. Several firms continue to use this hexagonal crystal form as a trademark. For example, both the Swarovski and the Kahles optical firms in Austria appropriately use a variation of "the sign" as a corporate logo.

[183] Bletter, Rosemarie Haag, "The Interpretation of the Glass Dream — Expressionist Architecture and the History of the Crystal Metaphor", 1981.

placing his art in the service of Icelandic independence, not achieved until 1947). As plaster is a ghost of a material, ivory and bone to the touch, evoking the secondariness of the replica, so this white plaster sculpture is ghost to its history, to the history of the crystal sign and its incarnation in sculpture.

In the garden is the bronze sculpture *Konungur Atlantis*(1919-1922). It is beginning to rain and a pyramidal crown shields the face of this "King of Atlantis". I remember the rainy obelisk behind the Metropolitan Museum in New York.

On a hillside overlooking the harbour is an Einar Jonsson sculpture, a monument to the Norwegian Viking Ingolfur Arnarsson. When Ingolfur approached the south coast of Iceland in 874, he threw overboard the two wooden pillars from his *høisæte* ("high seat", a rustic throne). He made his new home at Reykjavik, where the pillars washed ashore. The twin pillars are a symbol of Reykjavik and appear on the civic crest.

In the middle of a downtown square are two hexagonal columns of basalt that disguise steam pipes. In the evening, when the stores and the government offices close, the square buzzes with bees[184] and skateboarders. The skaters transform the abandoned downtown architecture, the steps and access ramps of banks and government buildings, into skateable structure. They seek, find and steal sculpture from the abandoned architecture.

Norse mythology records that Odin killed Ymir, the frost giant, broke his spine to create mountain ranges, planted his hair as forests, and drained his blood into seas. His skull was raised to become the vault of the sky and into this his brains were thrown to become the clouds and the mists. On the shore of the new sea, Odin found two pillars washed ashore. He planted them side-by-

[184] There are very few natural insects in Iceland. Bees are a curiosity. They have recently been introduced from mainland Europe to Reykjavik. In the street, children sell captive bees imprisoned inside six-sided glass jars that once contained honey.

side to become an elm tree and an ash tree. Following the outline cast by his own shadow he carved Embla, the first woman, from the elm tree. From the ash tree he carved Askr, the first man. His feet traced an elliptical path around the two pillars as he carved.[185] The woodchips were ground underfoot.

"… outdoor sites, in which dispersed elements again function like surrogate horizons across the field … require that the entire terrain be traversed in order to experience the work."[186]

On the island of Viðey (Wood Island) in Reykjavik Harbour are some ruins, a protected area for the nesting of eider ducks, and Iceland's oldest standing (Danish) stone structure. A small peninsula of the island, Vesturey is encircled by a Richard Serra sculpture: *Afangar (Stations, Stops on the Road, to Stop and Look: Forward and Back, To Take It All In)*, 1990. The sculpture consists of nine vertical pairs of naturally prismatic basalt pillars. The stones of each pair are placed at an elevation of 9 and 10 metres, respectively. The stone set at the higher elevation is 3 metres tall and the stone set at the lower elevation is 4 metres tall, so that each pair of stones is level at the top. The topography varies, so some stones are close together, others further apart. It is the same material that Joseph Beuys used in *7000 Oaks*, but more distinctly prismatic and grey-black rather than grey-brown.

Clockwise, we follow a narrow gravel path from each pair of pillars to the next, above a broken edge of basalt cliffs. We then trace elliptical orbits around each pairing. The Sculptor poses, as if for photographs, inside the variable framed views of the

[185] Carpenters draw an ellipse by stretching a loop of string over the heads of two nails driven into a board. A pencil is placed within the loop and the loop is stretched to its maximum length. An ellipse can then be drawn on the board.

[186] Lynne Cooke, *Richard Serra: Torqued Ellipses.*

landscape. She tells me about the *Domhring*, a circle of stone statues surrounding a pillar in front of Thor's temple at *Asgard*. (Every age gets the Stonehenge, the dinosaur and the *Domhring* that it wants.) She argues that by comparison, the Serra sculpture is mere kitsch, citing its reference to the over-told story of Ingolfur and the two pillars. I half-protest, reminding her of Joseph Beuys, his pairing of basalt stones with the trees along West 22nd Street. This seems to only confirm her opinion of the Serra sculpture. The gravel path has a fiberglass underlay to stop it from sinking. This sticks up through the gravel, like evidential clothing from a secretly buried corpse. The path is familiar with the memory of other travel. I walk behind the sculptor, but not always in her footsteps.

There are still more of the basalt goalposts on the horizon when, about halfway around the circuit, the easy walking path comes to an end. Now we must walk through wet dune grass. It is cold, windy and raining. I suggest that we turn back. I argue that the last boat to the mainland is leaving soon. Suddenly enthused, the Sculptor stresses that it is necessary to continue the circuit. Only at the end, she insists, will we be able to see that the tops of all the pairs of columns are level with one another and also level with the horizon. She argues that only then will we be able to see that we have actually been travelling around the rim of an immense horizontal bowl. She spins to wave her arms at the horizon. Overwhelmed by vertigo, she staggers forward into the tall serrations of the dune grass. First her legs disappear, then her torso. Now it is only her talking head, blonde jasper. I turn back.

BIBLIOGRAPHY

Adams, David. "From Queen Bee to Social Sculpture: The Artistic Alchemy of Joseph Beuys". *BEES, Lectures by Rudolph Steiner.* Transl. Thomas Braatz. Hudson, N.Y.: Anthroposophic Press, 1998.

Allen, Roger Macbride. "Evolving Conspiracy". *Dinosaur Fantastic,* New York: DAW Books 1993.

Andreotti, Margherita. *The Early Sculpture of Jean Arp.* Ann Arbor/London: UMI Research Press, 1989.

Andre, Carl. "Robert Smithson: He Always Reminded Us Of The Questions We Ought To Have Asked Ourselves". *Artsmagazine (Special Issue: Robert Smithson)* (May, 1978), p. 102.

Bacot, Jacques. *Le Poete Tibetiane Milarepa.* Paris: Brossard, 1925.

Ballard, J.G. *The Crystal World.* London: Jonathan Cape, 1966.

——————————. *Concrete Island.* London, Panther, 1976.

Barr, Margaret Scolari. *Medardo Rosso.* New York: The Museum of Modern Art, 1963.

Barthes, Roland. *The Pleasure of the Text.* New York: Hill and Wang, 1975.

Baudrillard, Jean. *Revenge of the Crystal.* London and Concord, Mass.: Pluto Press, 1990.

Baudrillard, Jean. *The Transparency of Evil, Essays on Extreme Phenomena.* London and New York: Verso, 1993.

Blake, William. *Jerusalem, The Emanantion of the Giant Albion.* Princeton, NJ: Princeton University Press for The William Blake Trust, 1991.

Blas, Edith. *Brancusi and Romanian Folk Traditions.* Boulder, Colorado and New York: Columbia University Press, 1987.

Bletter, Rosemarie Haag. "The Interpretation of the Glass Dream — Expressionist Architecture and the History of the Crystal Metaphor". *Journal of the Society of Architectural Historians*, Vol. XL, No. 1, (March, 1981).

Bose, Nirmal Kumar. *Canons of Orissan Architecture*. Calcutta: R. Chatterjee, 1932.

Boutell, Charles. *Arms and Armour in Antiquity and the Middle-Ages*. London: Reeves and Turner, 1874.

Brezianu, Barbu. "The Beginnings of Brancusi". *Art Journal*. XXV/I (1965), pp. 15-25.

Buck-Morss, Susan. *The Dialectics of Seeing, Walter Benjamin and the Arcades Project*. Cambridge, Mass.: MIT Press, 1989.

Brodzky, H. *Henri Gaudier-Brzeska*, London: Faber, 1933.

Broadbent, Geoffrey. "Deep Structures of Architecture". *Signs, Symbols and Architecture*. Broadbent, Geoffrey; Bunt, Richard; Jencks, Charles, eds. Chichester: John Wiley & Sons, 1980.

Burstow, Robert. "Butler's Competition Project for a Monument to 'The Unknown Political Prisoner' ": *Abstraction and Cold War Politics*, Art History (Vol. 12) No. 4, Dec. 1989.

Campbell, Joseph. *The Masks of God: Oriental Mythology*. New York: Viking Press, 1962.

Causey, Andrew. *Sculpture Since 1945*. London: Oxford University Press, 1998.

Codreane, Irene. "Aphorisms of Brancusi". *This Quarter*, 1/1 (1925), pp. 235-236.

Cohen, David. "Out of India: Hindu Spirituality in Recent British Sculpture". *Sculpture*, Vol. 13, No. 1 (Jan-Feb, 1940).

Cole, L. Herber. *The Gypsum Industry of Canada*, Ottawa, Canada: F.A. Acland, 1930.

Cole, Robert. *Burning to Speak, The Life and Art of Henri-Gaudier-Brzeska*. London: Oxford University Press, 1978.

Cowl, R. Pape. *A Great Icelandic Sculptor Einar Jónsson*. Reykjavik: The National Einar Jónsson Gallery, 1980.

Cooke, Lynne, Michael Govan and Mark Taylor. *Richard Serra: Torqued Ellipses*. New York, Dia Center for the Arts, 1997.

Copland, Ian. *The British Raj and the Indian Princes: Paramountcy in Western India, 1857-1930*. Bombay: Orient Longman, 1982.

Curtis, Penelope and Alan G. Wilkinson. *Barbara Hepworth*. London: Tate Gallery Publications, 1994.

D'Alton Martina. *The New York Obelisk*. New York: The Metropolitan Museum of Art/Abrams. 1993.

Deleuze, Gilles and Felix Guattari. *Nomadology: The War Machine*. New York: Semiotext(e), 1986.

Dhar, Sailendra Nath. *The Indore State and its Vicinity*. Indore: Indian Science Congress Twenty-Third session, 1936.

Doyle, Sir Arthur Conan. *The Lost World*. New York: Hodder and Stoughton, 1912.

Ede, H.S. *Savage Messiah; Gaudier-Brzeska*. New York: Alfred A. Knopf, 1931.

Ellis, W.S. "Romania, Maverick on a Tightrope". *National Geographic*, (November, 1975) pp. 24-37.

Elsen, Albert, E. "Interview",*Sculpture*, (January-February, 1995), pp. 10-13.

Foster, Hal. *Richard Serra, Sculpture 1985-1998*. Los Angeles, The Museum of Contemporary Art, 1999.

Frampton, Kenneth. *Modern Architecture, A Critical History*. London: Thames and Hudson, 1980.

Gaudier-Brzeska, Henri. "Vortex Gaudier-Brzeska". *Blast*, No. 1, (June, 1914). n.p.

Geist, Sidney. *Brancusi, A Study of the Sculpture*, New York: Grosman, 1968
——————. *Brancusi/The Kiss*. New York: Harper and Row, 1978.

Genet, Jean. *L'Atelier d'Alberto Giacomett*. Paris: Barbezat, 1958.

Gibbon, Edward. Womersely, David (ed.) *The History of the Decline and Fall of the Roman Empire,* New York: Viking Penguin 1995 (1783).

Gordon, C.D. *The Age of Attila, 5th Century Byzantium and the Barbarians*. Ann Arbor: University of Michigan, 1960.

Govinda, Lama Anagarika. *Psycho-Cosmic Symbolism of the Buddhist Stupa*. Emeryville, California: Dharma, 1976.

Guizot, M. *General History of Civilization in Europe (From the Fall of the Roman Empire to the French Revolution)*. New York: D. Appleton, 1840.

Hamlin, I. (ed.). *Forms and Functions of 20th Century Architecture*. Vol. 2, New York: Columbia, 1952.

Hamon, Philippe. *Expositions*. Berkley, Los Angeles, Oxford: University of California Press, 1992.

Harbison, Robert. *Eccentric Spaces*. New York: Alfred A. Knopf, 1977.

Harbison, Robert. *The Built, The Unbuilt, and the Unbuildable,* Cambridge, MA: MIT Press, 1991.

Hatto, A.T. *Nibelungenlied.* London: Penguin Classics, 1962.

Heyerdhal, Thor. *Fatu-Hiva.* Garden City, NY: Doubleday and Company, 1974.

Hillis, R.K. "Visual Aspects of Prana". *Oriental Art*, London, (Autumn 1969)

Hocart, A.M. *Origin of the Stupa.* Colombo: Journal of the Royal Architectural Society, Ceylon Branch, 1920.

Hohl, Reinhold. *Giacometti.* Bonn: Verlag Gerd Hatje, 1998.

Holme, Charles (ed.) *Peasant Art in Austria and Hungary.* London, Paris, and New York: "The Studio" Ltd., 1911.

Holmes, Major Don, "Shooting the Kalashnikov". *Rifle*, No. 117, Prescott, AZ: Wolfe Publishing, (1983)

Hughes, Thomas. *Tom Brown's School Days.* New York: Harper and Bros., 1980.

Jagger, Sergeant. *Modelling and Sculpture in the Making.* London: The Studio Ltd., 1933.

Jettmar, Karl. *Art of the Steppes.* New York: Greystone Press, 1967.

Johnson, Geraldine A. (ed.) *Sculpture and Photography.* Cambridge MA: Cambridge University Press, 1998.

Jónsson, Einar. *Myndir.* Reykjavik: Kaipmannahöfn Prentsmiðja Martius Truelsens, 1925.

—————————. *Myndir II.* Reykjavik: Ríkisprentsmiðjan Gutenberg, 1937.

Kramer, Hilton. *Brancusi: The Sculptor as Photographer.* London: David Grob Editions, 1979.

Kuspit, Donald. "Anish Kapoor". *Artforum*, Vol. 25, (November, 1986).

Lee, Vernon. *Laurus Nobilis: Chapters on Art and Life.* London: John Lane/ Bodley Head, 1909.

Lubbock, Tom. "The Shape of things Gone" *Modern Painters*, (Autumn 1997).

Mackay, James. *The Animaliers, The Animal Sculptors of the 19th and 20th Centuries.* London: Ward Lock Ltd., 1973.

Melville, Herman. *Moby Dick.* 1851.

McGinnis, H.J. *Carnegie's Dinosaurs*. Pittsburgh PA: Carnegie Institute, 1982.

Mocioi, Ion. *Brancusi: Ansamblul Sculptural De La Tîrgu Jiu*. Tîrgu Jiu, Romania: Comitetul Pentru Cultura Is Arta Al Judetului Gorj, 1971.

Nauman, Francis. "From Origins to Influence and Beyond: Brancusi's Column Without End". *ArtsMagazine*, 59, No. 9 (May, 1985), pp. 112-118.

Naylor, Gillian (ed.). *William Morris by Himself, Design and Writings*. Boston: Little, Brown, 1988.

Newton, Helmut. *White Women*. Munchen: Rogner and Berngard, 1976.

Olson, Ludwig. "The French Lebel". *Rifle*, No. 99, Wolfe Publishing, Prescott, AZ, (1985).

Pater, Walter. "Chapter II, White Nights". *Marius The Epicurean*. London: MacMillan and Co., 1903.

Penny, Nicholas. *The Materials of Sculpture*. New Haven and London: Yale University Press, 1993.

Pehnt, Wolfgang. *Expressionist Architecture*. Stüttgart: Verlag Gerd Hate, 1973.

Peterson, Daniel. "The Magic of the Mauser". *Rifle*, No. 96, Wolfe Publishing, Prescott, AZ, (1984).

Pinault, Madelaine. *The Painter as Naturalist, From Durer to Redoute*. Paris: Flammarion, 1991.

Poertner, Rudolph. *The Vikings: The Rise and Fall of the Norse Sea Kings*. New York: St. Martin's Press, 1971.

Pollack, R. "Brancusi's Sculpture vs. His Homemade Legend". *Art News*, LVIII, (February, 1960), pp. 26-27, 63-64.

Pound, Ezra. *Gaudier-Brzeska: A Memoir*. London/New York: John Lane/ Bodley Head, 1916.

Praz, Mario. *On Neo-Classicism*. London: Thames and Hudson, 1972.

Rawiez, Slavomir. *The Long Walk*. London: Pan Books, 1959.

Read, Herbert. *The Art of Sculpture*. New York: Pantheon, 1956.

Rose, W.K. *The Letters of Wyndham Lewis*. Nordfolk, Conn.: New Directions, 1963.

Rosenstock, Sami. "Money Themes". *Women Artists News,* (Winter 1989).

Ruskin, John. *Aratra Pentelici, Seven Lectures on the Elements of Sculpture*. New York: Charles Merrill & Co., 1892.

Rutherford, Adam. *Iceland's Great Inheritance*. Thousand Oaks, California: Artisan Sales, 1990.

Rykwert, Joseph. *On Adams House in Paradise*. New York: Museum of Modern Art, 1972.

Schwartz, Frederick. "Commodity Signs: Peter Behrens, the AEG, and the Trademark". *Journal of Design History*, Vol. 9, No. 3 (1996) pp. 153-184.

Serra, Richard. *Richard Serra Sculpture 1985-1998*. Los Angeles: Museum of Contemporary Art, 1999.

Sheerbart, Paul. *Glasarchitektur*. Berlin: Verlag der Sturm, 1914.

Smithson, Robert. "Incidents of Mirror Travel in the Yucatan". *Artforum*, (September, 1968).

Spear, Athena Tacha. "The Sculpture of Brancusi". *Burlington Magazine*, CXI, (March, 1969), pp. 154-158.

—————————. *Brancusi's Birds*. New York: New York University Press, 1969.

Spengler, Oswald. "Form and Actuality". *The Decline of the West*. Vol. 1, New York: Alfred A. Knopf, 1928.

Stevenson, Robert Louis. *Travels with a Donkey in the Cevennes*. Boston: Roberts Brothers, 1879.

Stewart, Susan. *On Longing*. Boston: John Hopkins University Press, 1984.

Stoker, Bram. *Dracula*. Westminster: Archibald Constable and Co., 1897.

Stokes, Adrian. *The Stones of Rimini*. New York: Schocken Books, 1969.

Stravinsky, Igor. "Stravinsky as seen by Giacometti — Giacometti as seen by Stravinsky". *Vogue*, New York (1958).

Stüttgen, Johannes. *Beschreibung eines Kunstwerkes*. Düsseldorf: Free International University, 1982.

Summers, Montague. *The Vampire in Europe*. New York: E.P. Dutton, 1929

Taylor, Robert R. *The Word in Stone, The Role of Architecture in National Socialist Ideology*. Berkley: Univ. of California Press, 1974.

Temple, Robert. *The Crystal Sun*. London: Arrow Press, 2000.

Thorburn, W.A. *French Army Regiments and Uniforms*. Harrisburg, Penn.: Stackpole Books, 1969.

Tolkien, J. R. R. *The Hobbit*, London: George Allen and Unwin, 1956.

Tucci, Giuseppe. *Stupa: Art, Architectonics and Symbolism*. New Delhi: Aditya Prakashan, 1988.

Twain, Mark, *Life on the Mississippi*, New York: James R. Osgood, 1883.

Verne, Jules. *A Journey to the Center of the Earth*. Boston: Henry L. Shepard, 1874.

Waldman, Diane. *Carl Andre*, New York: Solomon R. Guggenheim Foundation, 1970, p. 6.

Wall, Jeff. *Dan Graham's Kammerspeil*. (Banff, Canada: Walter Phillips Gallery, 1983.) Toronto: Art Metropole, 1991.

Wees, W.C. *Vorticism and the English Avant Garde*. Toronto: University of Toronto Press, 1972.

White, T.H. *The Goshawk*. London: Johnathan Cape, 1951.

Wilkinson, A.G. *The Moore Collection in the Art Gallery of Ontario*, Toronto: Art Gallery of Ontario, 1979.

Whyte, Ian Boyd. *The Crystal Chain Letters, Architectural Fantasies by Bruno Taut and His Circle*. Cambridge, MA: MIT Press, 1985.

About the Author

Robin Peck was born and grew up in rural Alberta, Canada. He had a memorable rural childhood but left Alberta in 1968.

He has worked as an artist, a writer on art, an independent curator and an educator. He has taught sculpture, art history and criticism in various universities and colleges and has lived in several North American cities including Halifax, Vancouver, and New York.

It was in Vancouver, British Columbia, during the mid-1980s that Robin Peck first began to develop a sculptural travelogue narrative within an essay format, a writing form that would be compatible with his experience of producing and viewing sculpture.

He exhibits at Canada, an independent art gallery in New York City and his essays appear regularly in a variety of international art publications.

In the late 1990s Robin Peck returned to rural Alberta, to live on the site of his grandfather's former ranch (est. 1890) where he has established his permanent studio and residence in the midst of a private wildlife refuge. From there it is a one-hour drive west to the Rocky Mountains, a one-drive hour east to the Red Deer River Badlands and a one-hour drive south to an international airport.

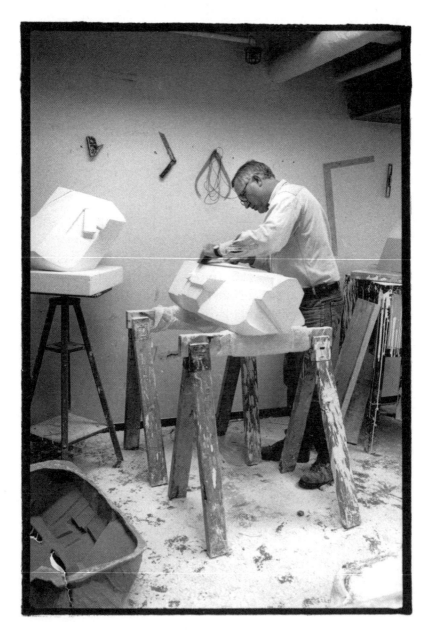

Robin Peck at work in his studio. Photo by Daniel Smith (1993).

Some of Our Arts-Related Publications
A Fredericton Alphabet (John Leroux) photos, architecture, ISBN 1-896647-77-4
Beauty and Myth (William Forrestall and Virgil Hammock) painting, exhibition catalogue,
 1-55391-027-3
Great Lakes logia (Joe Blades, editor) art & writing anthology, 1-896647-70-7
Jive Talk: George Fetherling in Interviews and Documents (Joe Blades, editor), 1-896647-54-5
Sustaining the Gaze / Sosteniendo la mirada / Soutenant le regard (Brian Atkinson, Nela Rio;
 Elizabeth Gamble Miller, Jill Valéry, translators) photos, poetry, 1-55391-028-1
The Longest Winter (Julie Doiron, Ian Roy) photos, short fiction, 0-921411-95-2
The Yoko Ono Project (Jean Yoon) drama, 1-55391-001-X
Wharves and Breakwaters of Yarmouth Co., Nova Scotia (Sarah Petite) pen & ink drawings,
 travel, 1-896647-13 8

A Selection of Our Other Books
All the Perfect Disguises (Lorri Neilsen Glenn) poetry, 1-55391-010-9
Antimatter (Hugh Hazelton) poetry, 1-896647-98-7
Avoidance Tactics (Sky Gilbert) drama, 1-896647-50-2
Bathory (Moynan King) drama, 1-896647-36-7
Break the Silence (Denise DeMoura) poetry, 1-896647-87-1
Crossroads Cant (Grace, Mark, Shafiq, Shin. Joe Blades, editor) poetry, 0-921411-48-0
Cuerpo amado / Beloved Body (Nela Rio; Hugh Hazelton, translator) poetry, 1-896647-81-2
Day of the Dog-tooth Violets (Christina Kilbourne) novel, 1-896647-44-8
During Nights That Undress Other Nights / En las noches que desvisten otras noches (Nela Rio;
 Elizabeth Gamble Miller, translator) poetry, 1-55391-008-7
Groundswell: the best of above/ground press, 1993-2003 (rob mclennan, ed.), 1-55391-012-5
Herbarium of Souls (Vladimir Tasic) short fiction, 0-921411-72-3
Mangoes on the Maple Tree (Uma Parameswaran) novel, 1-896647-79-0
Manitoba highway map (rob mclennan) poetry, 0-921411-89-8
Memories of Sandy Point, St George's Bay, Newfoundland (Phyllis Pieroway), social history,
 1-55391-029-X
Maiden Voyages (Scott Burke, editor) drama, 1-55391-023-0
Paper Hotel (rob mclennan) poetry, 1-55391-004-4
Reader Be Thou Also Ready (Robert James) novel, 1-896647-26-X
resume drowning (Jon Paul Fiorentino) poetry, 1-896647-94-4
Shadowy: Technicians: New Ottawa Poets (rob mclennan, editor), poetry, 0-921411-71-5
Singapore (John Palmer) drama, 1-896647-85-5
Song of the Vulgar Starling (Eric Miller) poetry, 0-921411-93-6
Speaking Through Jagged Rock (Connie Fife) poetry, 0-921411-99-5
Starting from Promise (Lorne Dufour) poetry, 1-896647-52-9
Sunset (Pablo Urbanyi; Hugh Hazelton, translator) fiction, 1-55391-014-1
Sweet Mother Prophesy (Andrew Titus) novel, 1-55391-002-8
Tales for an Urban Sky (Alice Major) poetry, 1-896647-11-1
This Day Full of Promise (Michael Dennis) poetry, 1-896647-48-0
The Sweet Smell of Mother's Milk-Wet Bodice (Uma Parameswaran) novella, 1-896647-72-3
Túnel de proa verde / Tunnel of the Green Prow (Nela Rio; Hugh Hazelton, translator) poetry,
 1-896647-10-3
What Was Always Hers (Uma Parameswaran) short fiction, 1-896647-12-X

www.brokenjaw.com hosts our current catalogue, book prices, submissions guidelines including a
manuscript award competition, booktrade sales representation and distribution information. Directly
from us, all individual orders must be prepaid. Canadian orders must add 7% GST/HST (CCRA
Number: 892667403RT0001). Broken Jaw Press, Box 596 Stn A, Fredericton NB E3B 5A6, Canada.